IMAGES
of Aviation

THE SIKORSKY
LEGACY

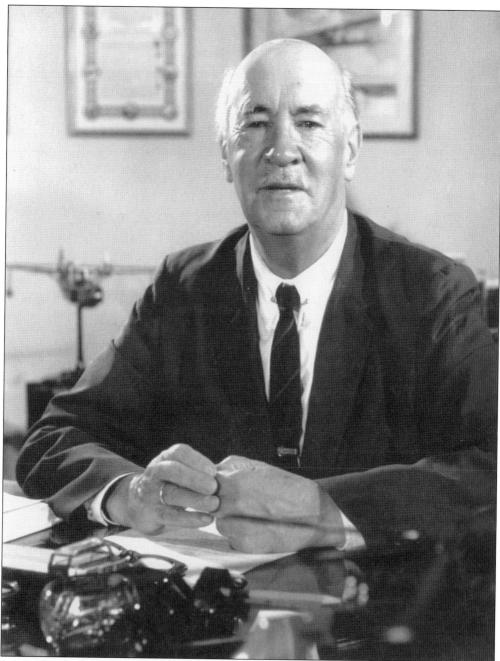

Igor I. Sikorsky (1889–1972) was born when the concept of a man-carrying aircraft was considered an impossible dream. He lived to see man walk on the moon. He was one of a small group of inspired pioneers who helped transform that impossible dream to reality.

On the cover: A U.S. Air Force H-19 helicopter hoists a crewman from a foundering U.S. Army tug off the coast of Okinawa in the 1950s, confirming Sikorsky's 1938 prediction that "the helicopter will prove to be a unique instrument for the saving of human lives." (Courtesy of the Igor I. Sikorsky Historical Archives.)

IMAGES
of Aviation

THE SIKORSKY
LEGACY

Sergei I. Sikorsky
with the Igor I. Sikorsky Historical Archives

ARCADIA
PUBLISHING

Copyright © 2007 by Sergei I. Sikorsky with the Igor I. Sikorsky Historical Archives
ISBN 978-0-7385-4995-8

Published by Arcadia Publishing
Charleston SC, Chicago IL, Portsmouth NH, San Francisco CA

Printed in the United States of America

Library of Congress Catalog Card Number: 2006939383

For all general information contact Arcadia Publishing at:
Telephone 843-853-2070
Fax 843-853-0044
E-mail sales@arcadiapublishing.com
For customer service and orders:
Toll-Free 1-888-313-2665

Visit us on the Internet at www.arcadiapublishing.com

CONTENTS

ACKNOWLEDGMENTS

This book owes much to the encouragement and tireless efforts of the members of the Igor I. Sikorsky Historical Archives, its president Daniel Libertino, senior advisor Harry Hleva, and editorial advisor Bill Tuttle. In addition to research and pictorial support by the archives, I wish to recognize a number of aviation historians, whose work was of great help in cross-checking and reconciling the sometimes conflicting Russian and early American data. They include V. A. Bargatinov's recently published Russian-language encyclopedia *Russian Wings*; Carl Bobrow's *The Beginning of Air Power: Russia's Long Range Strategic Reconnaissance and Bomber Squadron 1914–1917*; *The Aviation Careers of Igor Sikorsky* by Dorothy Cochrane, Von Hardesty, and Russell Lee; Frank Delear's *Igor Sikorsky: His Three Careers in Aviation*; Vadim Mikheyev's definitive Russian-language book *Sikorsky*; Harry Pember's *Sikorsky Aircraft—Pioneers of Vertical Flight*, and other works on Sikorsky history; V. B. Shavrov's *History of Aircraft Construction in the U.S.S.R.*, and I. A. "Prof" Sikorsky's unpublished manuscript, "The Technical History of Sikorsky Aircraft and Its Predecessors Since 1909." Also, Igor Sikorsky's own autobiography, *The Story of the Winged-S*; the revered John W. R. Taylor's *Sikorsky* in the Images of America series; and last, but certainly not least, Harry Woodman's detailed articles and three-view drawings of the Grand, the Ilya Muromets series, and the S-29A, to name a few of his many works. My special thanks to my wife, Elena, for her help and support. My apologies to anyone I may have inadvertently omitted.

And, beyond that, the unforgettable memories of many fascinating hours spent with my father, both in the air and on the ground, while discussing some of the aircraft remembered in this book.

Sergei I. Sikorsky
Surprise, Arizona

INTRODUCTION

Igor Ivanovich Sikorsky was born on May 25, 1889, in Kiev, the capital of Ukraine, at that time an important part of the Russian Empire. He was the youngest of the five children of a prominent doctor and psychiatrist, Prof. Ivan A. Sikorsky. His mother, Zinaida, a medical school graduate, gave up a promising career to care for the growing family. Igor's four siblings were Lydia, Olga, Elena, and his brother, Sergei. Sergei perished during World War I while serving in the Russian Navy aboard a cruiser. The vessel was hit by a German torpedo, leaving few survivors.

At an early age, Igor began to show a strong interest in mechanics, building his own toys and even a small electric motor powered by glass jars converted into batteries. His family encouraged his mechanical talents and his interest in technology. A room in the back of the Sikorsky home was given to him as his workshop.

As he grew older, his mother showed him Leonardo da Vinci's sketches of machines, war chariots, and giant ballistic catapults. Igor was especially fascinated by da Vinci's sketches of man-powered flying machines and the description of a helicopter. He read all the science fiction novels of Jules Verne but was particularly impressed by the description of a helicopter-like machine in Verne's *Robur the Conqueror*. Igor's dream of building a flying machine was not dampened by the opinion of most respected scientists that mechanical flight would forever be technically impossible. Even as a child, he was determined to fly someday.

In 1900, at the age of 11, he had a prophetic dream that would influence his life. In his dream, he found himself walking down a narrow passageway with luxurious decorations and walnut cabin doors on each side. He felt a faint vibration, unlike that of a train or steamer, and suddenly realized that he was in a flying machine! He awoke, bolt upright in bed. The dream was so realistic and so powerful that it would remain unforgettable for the rest of his life.

At the age of 12, he built a rubber band–powered, contra-rotating helicopter. The helicopter was fairly large; the two rotors had a diameter of some 30 inches. To his delight, it could rise several feet into the air before it would settle back to the ground as the rubber bands unwound.

In 1903, 14-year-old Igor postponed his hope of someday building an aircraft and entered the Imperial Naval Academy at St. Petersburg. After three years at the academy, he decided that he was more interested in engineering than in a career as a naval officer. He resigned from the academy in 1906 and returned to Kiev and his beloved workshop. His decision to study engineering was reinforced by vague, mostly inaccurate newspaper reports of the Wright brothers' flights, and the first "hops" of Alberto Santos-Dumont and Farman in Paris.

In 1907, he enrolled in the Kiev Polytechnical Institute. While studying there, he also worked on a number of projects in his workshop, including building a steam-powered motorcycle.

In the summer of 1908, Igor's father took him to Bechtesgaden in the Bavarian Alps on vacation. The local newspapers were enthusiastically reporting on the fact that a one-day fund-raising

campaign had netted enough money to replace the LZ-4 airship of Count Zeppelin, which had crashed a few days earlier. However, the critical moment came in August when Igor read a detailed eye-witness account, with photographs, of Wilbur Wright's first flight demonstrations at Le Mans, France. All of Igor's earlier dreams and fantasies came back in a rush. He was puzzled that the article was buried inside and not headlined on the front page.

He reread the accurate description of the flights and studied the photographs. Within hours, Igor made the firm decision to dedicate his life and creative work to aviation. He was 19 years old.

One

THE RUSSIAN YEARS

Igor Sikorsky returned from Germany in late summer of 1908, determined to enter aviation. By the end of the year, he had collected all the information he could find about aeronautics. He built several stands to test rotor thrust and lift, increasingly fascinated by the concept of the helicopter.

Impressed by his tenacity, his older sister Olga gave him money to travel to Paris, then the center of the aviation world. From January to April 1909, he studied the dozens of airplanes to be found on the airfields around Paris. Some were capable of brief hops but most stayed firmly on the ground. He met such aviation pioneers as Capt. Ferdinand Ferber and Louis Bleriot. It was Ferber who advised young Sikorsky: "Do not waste your time on a helicopter. The airplane will be far more valuable." Sikorsky bought a 25-horsepower Anzani aircraft engine, returned to Kiev, and built his first aircraft—a helicopter.

After testing the helicopter, Sikorsky realized it would never fly. A second helicopter, built in the spring of 1910, was capable of lifting itself in the air but lacked the power to fly with a man in it. He "temporarily postponed" the helicopter and built his first airplane, the S-1. Incapable of flight, it taught Sikorsky how to control a fast-moving airplane on the ground. The S-2 and S-3 could barely hop and were quickly crashed, as was the S-4. The S-5, with a 50-horsepower Argus engine was, in Sikorsky's words, his first real airplane. With it, he made his first true flight on May 11, 1911, climbing to 300 feet and circling the airfield before landing. By the summer of 1911, he was flying one hour in the sky over Kiev, reaching altitudes of 1,500 feet.

In August 1911, Sikorsky received his Federation Aeronautique Internationale (FAI) pilot's license and set four Russian records for altitude, speed, range, and endurance with the S-5. A few weeks later, as he was demonstrating the aircraft at a country fair near Kiev, the engine suddenly stopped just after takeoff. Sikorsky was 150 feet in the air. The only open landing area was a railroad switchyard dead ahead. Sikorsky deliberately crash-landed the S-5 to avoid hitting a stone wall. Upon examining the cause of the crash, he found that a mosquito had lodged in the carburetor jet, choking off the fuel. The crash started Sikorsky thinking about the advantages of a multiengined aircraft, and he began making sketches.

The new S-6A, powered by a 100-horsepower Argus engine, won the Great Gold Medal in February 1912, as the best aircraft at the Moscow Aeronautical Exhibition. This attracted the attention of the chairman of the Russian-Baltic Railcar Factory, or RBVZ, one of Russia's industrial giants. In April, 23-year-old Igor Sikorsky accepted an offer to become chief engineer and test pilot of the RBVZ's newly formed aviation department. His first task was to redesign the S-6A for an important military competition to take place in September 1912, to be piloted by Igor Sikorsky.

On September 17, during the competition, Sikorsky was invited to dinner by the chairman of the RBVZ, Gen. Michael V. Shidlovsky. The conversation turned to the future of aviation. Sikorsky described his vision of a large, comfortable "airliner" powered by several engines. He ended his

description by offering his share of the prize, if he won, to build the aircraft. The chairman said: "no . . . start immediately!"

On September 30, 1912, Igor Sikorsky won the competition. His share of the prize money was used to repay his family. On May 10, 1913, his airliner (nicknamed the Grand) first flew with two engines to test stability and control. Then two more engines were added as "pushers" behind the front engines. It was the first four-engined aircraft in aviation history to fly successfully. Sikorsky then relocated the engines four abreast, resulting in greatly improved flight performance during flight tests in July 1913. Later that month, the Grand set a record by flying for 1 hour and 50 minutes over St. Petersburg while carrying eight passengers. It is interesting to note that this was only nine and a half years after the Wright brothers' first flight!

In late July 1913, Igor Sikorsky was advised that Czar Nicholas II was interested in viewing the Grand. Sikorsky flew to a nearby military airport and was able to show the aircraft to the czar during a rare one-on-one meeting on the aircraft. A few days later, Sikorsky received a diamond-studded gold watch as a gift from the czar. The watch would become one of his prized possessions.

An improved version of the Grand, named after a legendary medieval warrior, Ilya Muromets, made a historic cross-country flight of 800 miles from St. Petersburg to Kiev in June 1914. As Igor Sikorsky flew back to St. Petersburg, World War I started. The Ilya Muromets was rapidly redesigned from a civil airliner into a long-range reconnaissance and bomber aircraft and put into production.

The production of the much-improved Ilya Muromets series can be summarized as follows:

Ilya Muromets type A (S-22)	First flight 1913	1 built
Ilya Muromets type Beh (S-23)	First flight 1913	6 built
Ilya Muromets type Veh (S-24)	First flight 1914	18 built
Ilya Muromets type Geh (S-25)	First flight 1915	55 built
Ilya Muromets type Deh (S-26)	First flight 1916	3 built
Ilya Muromets type Yeh (S-27)	First flight 1916	2 built
	Total:	85 built

The Ilya Muromets Geh model was produced in four variants and was often modified from the original Geh-1 into a -2, -3, or -4 either at the RBVZ factory or in the field. Three Geh-2s were modified to carry the first tail gunner station in aviation history.

Incomplete records show that the average operational life on an Ilya Muromets in the harsh Russian climate was between eight and ten months before it was written off. The causes included combat damage, storm damage, training accidents, and weakening of the wooden structure and fabric, often due to inadequate hangar facilities.

The four-engined Ilya Muromets was by far the biggest aircraft in military service during most of World War I. Igor Sikorsky shuttled between the frontline bases and the RBVZ factory in St. Petersburg, training new pilots to fly the aircraft and constantly improving the basic design. Thanks to its many defensive machine guns, these giant aircraft carried out hundreds of combat missions, and only one craft was lost to enemy fighters.

In late 1917, the Bolshevik revolution plunged Russia into chaos. Igor Sikorsky was warned that his life was in danger. In March 1918, Sikorsky boarded a freighter in Murmansk: its destination, Liverpool, England. From there, he found his way to Paris and was immediately tasked to design a new bomber for the French. However, the war ended in November 1918, and all military contracts were cancelled. After some deliberation, Igor Sikorsky decided to leave Europe. In March 1919, he arrived in America with $600 cash (and the czar's watch) and no firm plans. He was, however, encouraged by the conviction that somehow America would give him the opportunity to resume his aviation career.

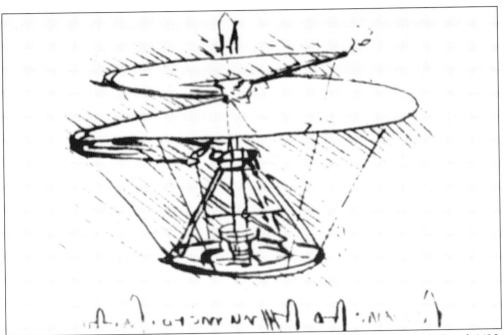

This sketch of Leonardo da Vinci's helicopter was made sometime between 1486 and 1490. Some aviation historians believe da Vinci may actually have flown such a model, powered by a very light steel spring. The sketch fascinated young Igor Sikorsky and sparked his interest in helicopters.

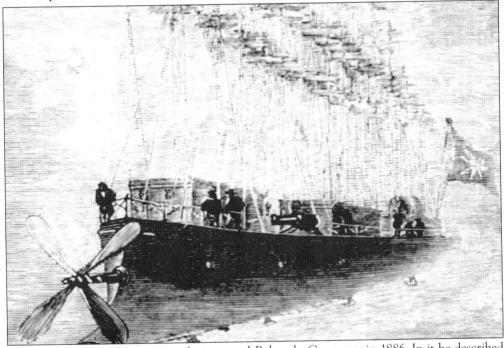

Jules Verne published his science fiction novel *Robur the Conqueror* in 1886. In it he described an imaginary helicopter capable of hovering while rescuing people in distress. It was probably young Sikorsky's favorite book. The English-language version is titled *Clipper of the Clouds*.

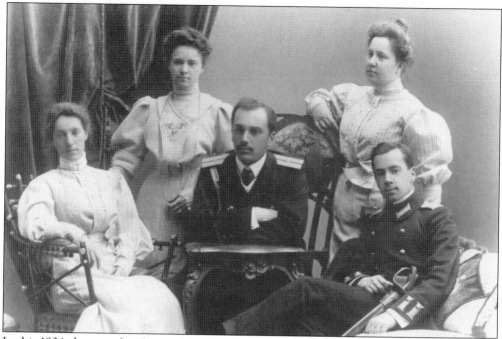

In this 1904 photograph, 15-year-old Igor Sikorsky is shown in his naval academy dress uniform (right). In the picture, from left to right, are Igor's sisters, Olga, Lydia, Elena, and his brother, Sergei. Olga, with some help from the parents, financed Igor's trip to Paris in early 1909.

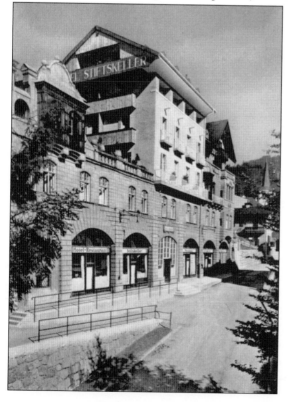

In August 1908, vacationing with his father in the German Alps, Igor was excited by the sensational photographs and newspaper accounts of Wilbur Wright's flights in France. In his hotel room in the Stiftskeller in Bechtesgaden, he began to design his first helicopter.

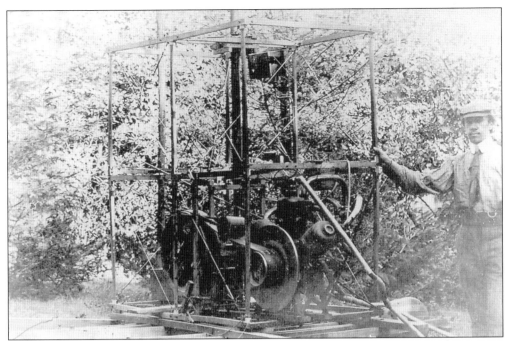

The H-1 helicopter was Igor's first attempt to design and build a flying machine, in the summer of 1909. The helicopter lacked the power to allow the crude rotor blades to lift the machine off the ground.

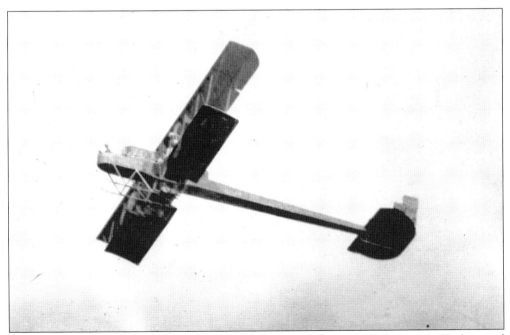

For Igor Sikorsky, the Grand was important for a number of reasons. In his words, "It shattered the myth . . . the superstition . . . prevailing at the time [1912–1913] that an airplane weighing more than one ton was impossible . . . it would never fly." The Grand also proved that an airplane could lose one engine and remain controllable, no matter which engine failed.

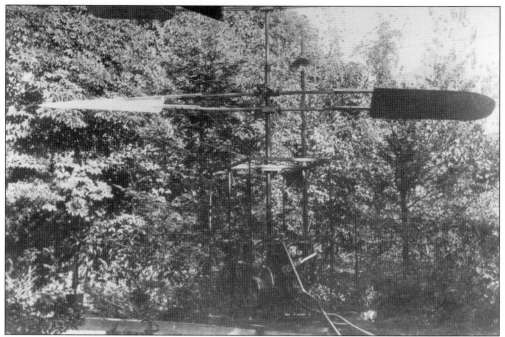

Igor Sikorsky's first aircraft was his first love, the helicopter. The H-1 was built in May through June 1909 and tested through the summer. A simple, wire-braced wooden cage held the 25-horsepower Anzani engine. After two months of testing, Sikorsky concluded that the 350-pound machine was too heavy to fly on 25 horsepower and was obviously unable to lift off with the added weight of a pilot.

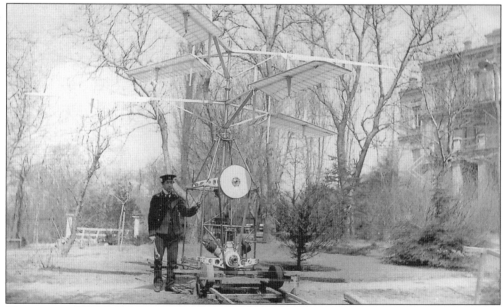

The improved H-2 helicopter was built and tested from February through May 1910. With the same 25-horsepower Anzani engine, and two new three-bladed rotors, it could barely lift itself off the ground, but not with a pilot. In late May, Sikorsky decided to "temporarily postpone" further helicopter work and test his first airplane, built at the same time as the H-2.

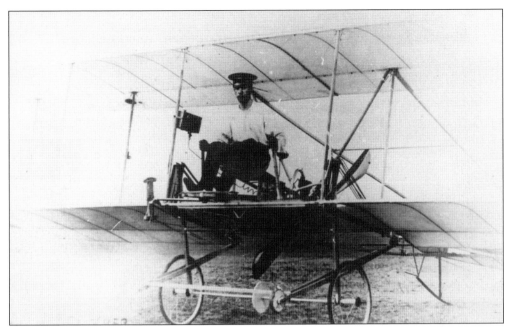

In May 1910, Sikorsky tested the S-1. Powered by a "pusher" 15-horsepower Anzani, it was incapable of flight but was invaluable in teaching Sikorsky how to steer the aircraft on the ground at high speeds. It had a wingspan of 26 feet and a gross weight of 550 pounds. After three weeks of testing, during which time one brief "hop" was achieved, the aircraft was taken apart and the major components used in the bigger S-2.

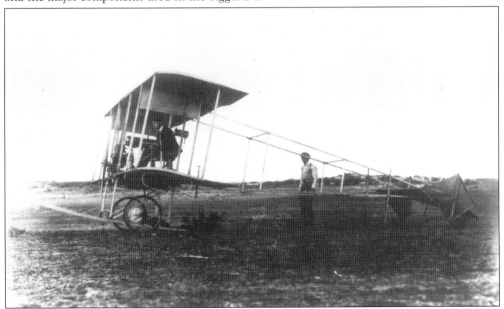

On the S-2, powered by a tractor 25-horsepower Anzani, Sikorsky made his first real flight of 12 seconds and some 200 yards on June 3, 1910. After a series of straight-line training flights, peaking at a 1,900-foot distance and a 42-second duration, on July 4, Sikorsky attempted a circuit of the field. Due to a downdraft, the aircraft stalled and crashed. Pilot uninjured, the aircraft was a total loss.

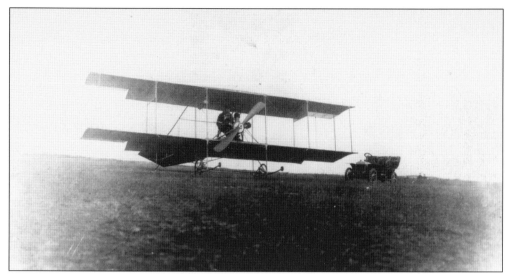

The S-3 was completed in late November 1910. Powered by a 40-horsepower Anzani engine, wingspan was 26 feet and the gross weight 685 pounds. It showed great promise, but its career lasted barely one week. On its 13th flight, on December 13, the distributor vibrated to "spark retard" position. The loss of power resulted in a forced landing on a frozen pond. The pilot was wet but unhurt.

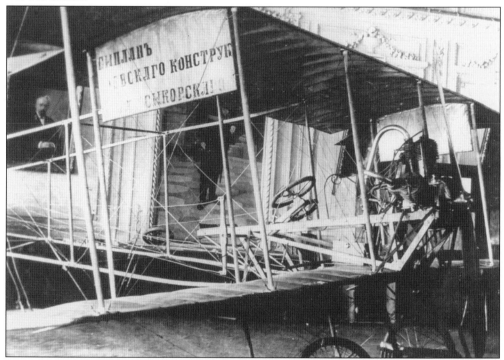

The S-4 used many parts from the crashed-damaged S-3, including the 40-horsepower Anzani engine and outer wing panels. Wingspan grew to 29 feet and gross weight to 795 pounds. It was shown at an aeronautical exhibition in Kharkov in the spring of 1911. By then, Igor Sikorsky had moved from the two-stick control scheme to a wheel-and-yoke system. The S-4 was scrapped as the superior performance of the S-5 became evident.

Sikorsky called the S-5 his first "real" airplane. Powered by a 50-horsepower Argus motor, it had a wingspan of 39 feet and grossed at 970 pounds. In September 1911, he flew the S-5 at military maneuvers at Fasova, near Kiev, where he met Czar Nicholas II for the first time. In October, the S-5 crashed after a mosquito clogged the fuel jet and the engine stopped.

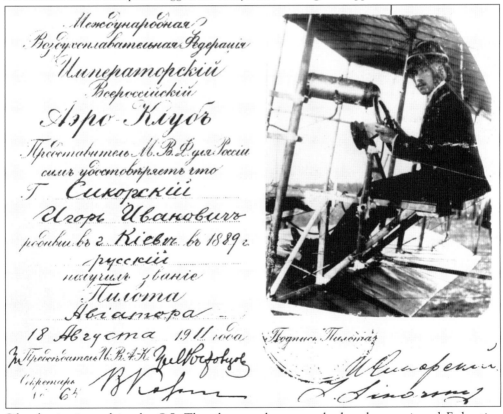

Sikorsky is pictured in the S-5. The photograph was used when he was issued Federation Aeronautique Internationale (FAI) Pilot's License No. 64 by the FAI's Russian office, dated August 18, 1911.

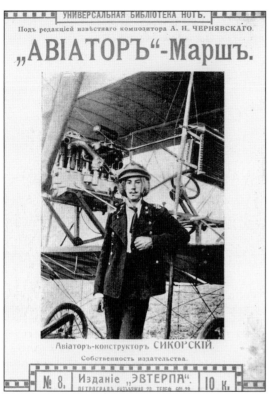

Igor Sikorsky is pictured on the cover of sheet music entitled "The Aviator March" in Russian. His fame as a Russian aviation pioneer was so well recognized that this music was composed in his honor.

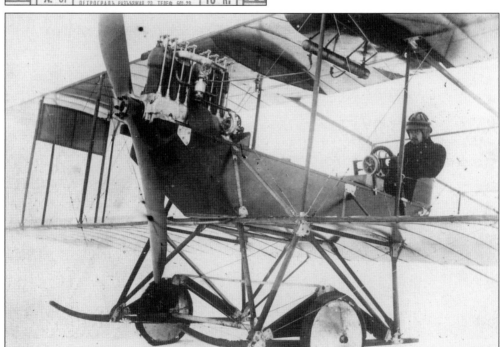

The S-6, powered by a 100-horsepower Argus engine, flew in November 1911. It had a wingspan of 38 feet and a maximum gross weight of 2,180 pounds. It had poor performance, largely due to the open framework rear fuselage and tail, which generated much drag.

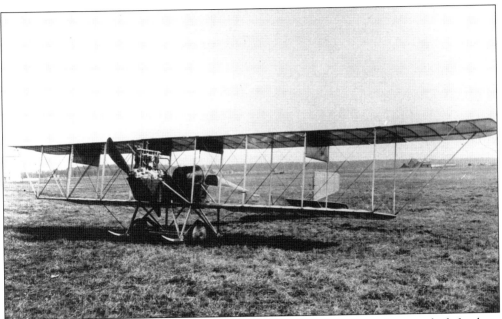

In an effort to reduce the drag, the S-6 was rebuilt with a slim plywood-covered aft fuselage. In March 1912, the S-6A established a new world record, carrying three people at a speed of 66 miles per hour. In April, the S-6A won first prize at the Moscow Aeronautical Exhibition and established Igor Sikorsky as Russia's leading aeronautical engineer.

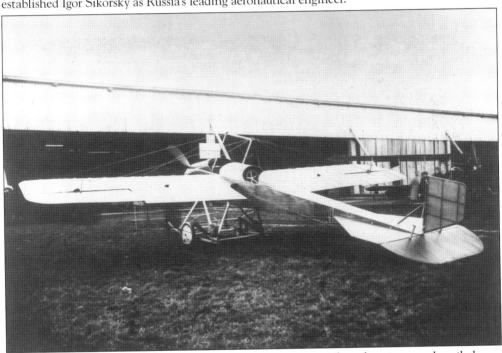

The S-7 was built in July 1912, using many parts of the S-6A, such as the wing panels, tail planes, and landing gear. It was powered by a 70-horsepower Gnome-Rhone engine and had a wingspan of 32 feet and a gross weight of 1,710 pounds. The two-seat aircraft was built for the 1912 military competition but was damaged during the trials. It was repaired and served well as a trainer.

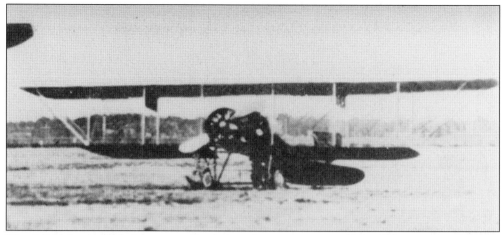

The S-8 Malyutka (baby) was a small side-by-side trainer, powered by a 50-horsepower Gnome. The wingspan was 39 feet, and it had a gross weight of 1,150 pounds. The control wheel was on a yoke and could be shifted from pilot to copilot's position. With this aircraft, Igor Sikorsky made his first night flight on September 17, 1912, landing with the help of bonfires lit by his ground crew.

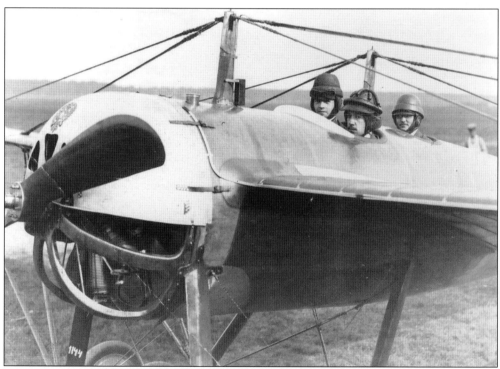

This close-up of the S-9 shows George Yankovsky (left) and Sikorsky in the front cockpit and Gleb Alechnovich in the rear cockpit. Note the RBVZ logo above the propeller blade. Built in the spring of 1913, with a 100-horsepower Gnome Monosoupape, it had a wingspan of 39 feet and was hopelessly overweight at 1,520 pounds empty and 2,200 pounds gross.

Sikorsky stands behind the aft cockpit of the S-10A in the RBVZ factory. This photograph was probably taken in mid-1913, shortly before the September military competitions.

The special competition S-10 (top) was built for 1913 trials with an 80-horsepower Gnome and wings extended by one bay. An S-10A is pictured (middle) with short wings and a 100-horsepower Anzani engine. The S-10B pictured (bottom) has extended four-bay wings and extra fuel tanks under the top wing. This could be the S-10 on which Gleb Alechnovich established a Russian record of 310 miles flown, in a flight lasting 4 hours and 56 minutes on September 25, 1913.

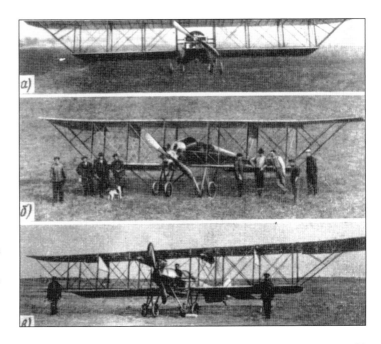

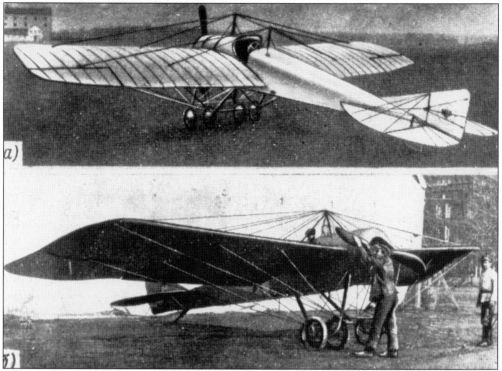

The upper photograph shows the S-11 Pologrugly, or "half-round." The airship hangar at Korpusnoi Airfield can be seen in the background. The lower photograph shows an S-12. Many of the dozen S-12s built survived World War I and were flown well into 1922 as trainer aircraft.

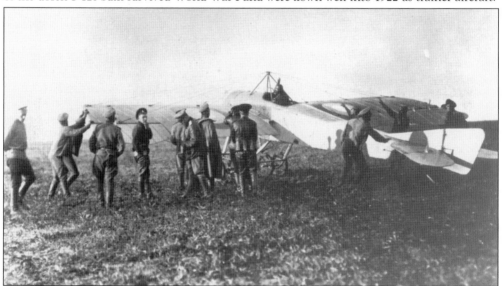

The S-12 was a smaller, single-seat version of the S-11, powered by an 80-horsepower Gnome. The wingspan was 33 feet, and gross weight was 1,500 pounds. Built at the suggestion of the RBVZ test pilot George Yankovsky, it was an immediate success. It was the first Russian aircraft to be looped, with Yankovsky at the controls. In October 1913, he set a Russian altitude record of 12,074 feet.

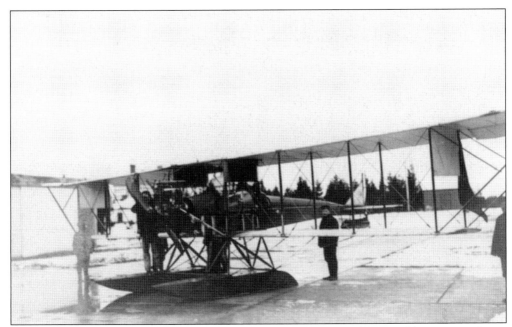

The S-15 was a highly modified variant of the S-10 series, powered by a 125-horsepower Argus As-III engine. Although the weight is unknown, the wingspan was 55 feet, and the maximum speed was about 60 miles per hour. Only one example was built. In midsummer 1914, it was converted from land gear to a floatplane configuration and assigned to the Russian Navy's Baltic Fleet. Records ended at this point.

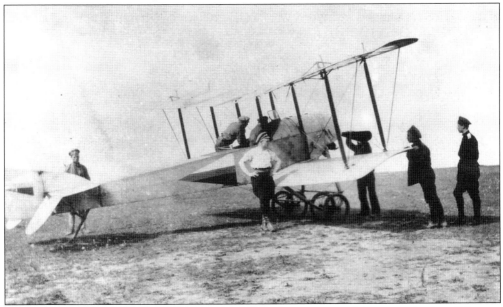

Three prototypes of the S-16 two-seat scout and single-seat escort fighter were built in February 1915, followed by 24 production machines in 1916 and early 1917. Most were powered by 80-horsepower Gnome engines or the Russian 60-horsepower Kalep. The wingspan was 26 feet, and the gross weight was 1,500 pounds. About six of the machines survived the war and served with the Red Air Force into the early 1920s.

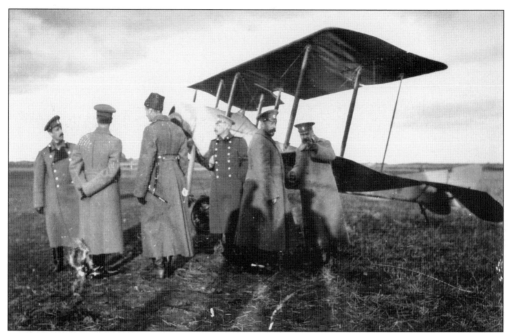

Gen. Michael V. Shidlovsky, commander of the Ilya Muromets squadron and CEO of the RBVZ (far right), shows the S-16 to Gen. N. V. Ruzky (second from the right) and staff officers at what is likely Vinnitsa Airbase in late 1916. (Courtesy of the V. Hardesty Archives.)

The S-18 was the result of a requirement for a long-range fighter. There is some evidence that it was designed by the Russian War Department and assigned to the RBVZ for construction and test. Two prototypes were built in late 1916, powered by two pusher 150-horsepower Sunbeam engines. The wingspan was 54 feet, and the gross weight was 4,600 pounds. Due to very poor performance, both aircraft were subjected to many modifications.

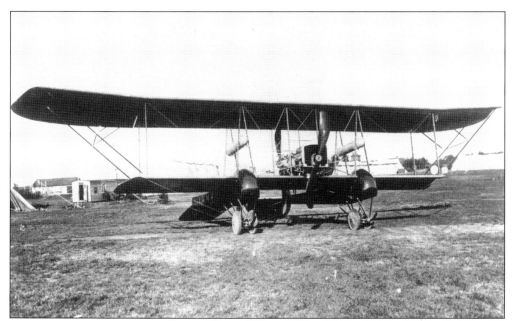

The S-19 seems also to have been designed by the war department, and then two were built by the RBVZ, also in late 1916. This is a twin-boom biplane, with each boom projecting forward of the lower wing, with one cockpit for the pilot and one for the gunner in the boom nose. The wingspan was 55 feet, and the gross weight is unknown. Two 150-horsepower Sunbeam engines, in a tractor-pusher installation, were mounted on the lower wing.

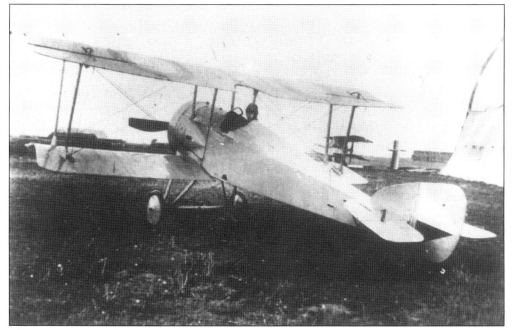

The S-20 was Igor Sikorsky's last and probably best fighter. Fitted with a 120-horsepower Gnome, it was test flown by Sikorsky in September 1916. The wingspan was 27 feet, the gross weight was 1,250 pounds, and the top speed was 118 miles per hour. After a successful frontline evaluation, five additional S-20s were delivered in early 1917.

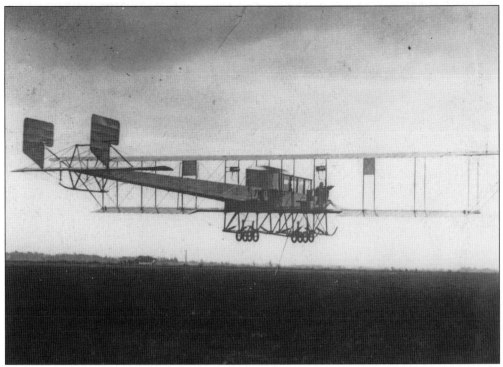

The first flight (landing) of the Grand twin-engined version was on May 10, 1913. Note the stick hanging from the aircraft used by Igor Sikorsky to measure height from the ground as he approached for landing. It was soon discarded.

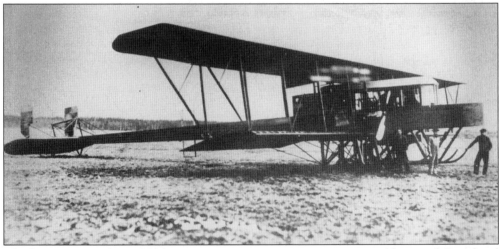

The first version, with two 100-horsepower Argus tractor engines, was quickly named Grand and nicknamed the "Flying Trolley-Car." The first flight was on May 10, 1913. The lower wing clearly shows a cutout at the trailing edge, probably to allow installation of the two pusher engines and propellers to make it into a four-engine aircraft.

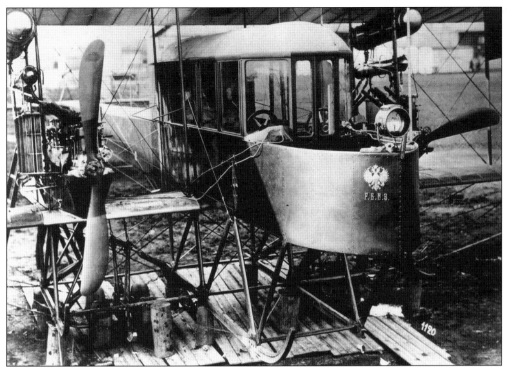

The second version, Bolshoi Baltisky (Big Baltic) with four 100-horsepower Argus engines, two back-to-back on each side of the fuselage, resulted in a two-tractor, two-pusher design. After a series of training hops, the first real flight was on May 13, 1913, by the old Russian calendar, or May 26 by the western Gregorian calendar.

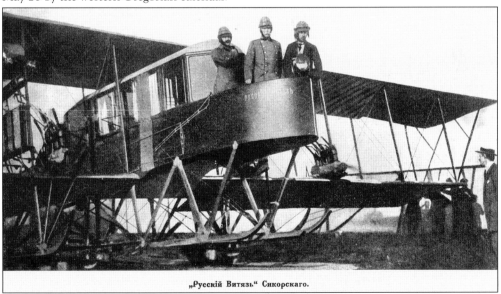

„Русскій Витязь" Сикорскаго.

The Russky Vityaz (Russian Knight) is shown with the four 100-horsepower Argus engines line-abreast on the lower wing. Two extra rudders were added, for a total of four. The cutout of the lower wing was reduced, adding about five square feet of area to the wing. This was the version shown to the czar at Krasnoye Selo in July 1913.

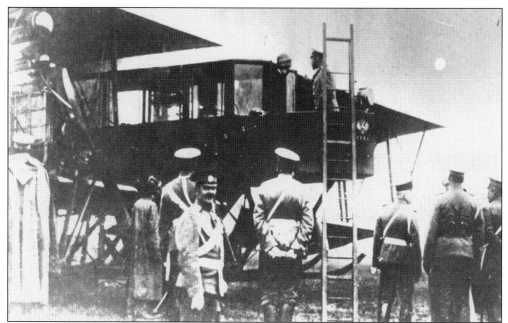

With a wingspan of 91 feet 10 inches, a length of 69 feet, and a takeoff weight of roughly 9,250 pounds, the Grand was by far the biggest and heaviest airplane in the world. In early July 1914, responding to an invitation by the czar, Igor Sikorsky flew it to the Krasnoye Selo military airfield, where it was inspected by Nicholas II. Above, the czar and Sikorsky confer on the front deck.

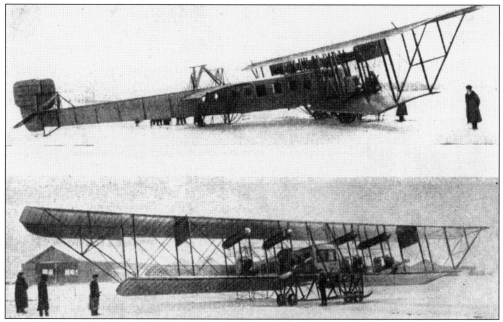

In the winter of 1913, the prototype Ilya Muromets was completed. Very few photographs exist showing the auxiliary wing, which was removed shortly after the aircraft started preliminary high-speed taxi tests. The first liftoff and straight-line "hop" to the opposite end of airport was on December 10, 1913. The first true flight out of Kurpusnoi airfield was made on January 26, 1914. The prototype would later be designated as the S-22.

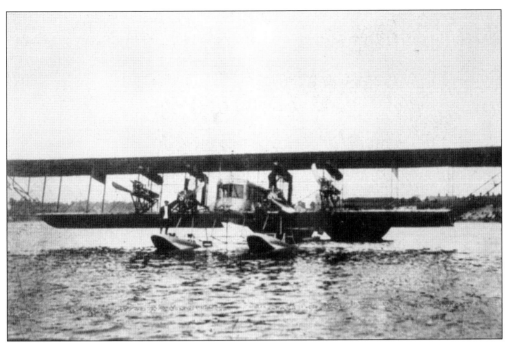

The prototype S-22 was modified in July 1914. It was re-engined with two 115-horsepower Argus engines outboard and two 200-horsepower Salmson engines inboard. Test flown by Sikorsky, it was by far the largest seaplane in the world. At the start of World War I, the aircraft was set on fire on the island of Osel (Saaremar) as a fleet of ships approached. They turned out to be Russian.

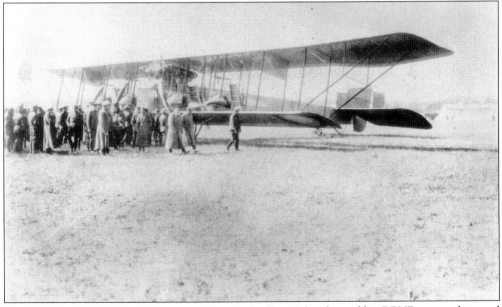

At the start of World War I, in a round-the-clock effort, Sikorsky and his RBVZ team redesigned the S-22 into the S-23 Beh model. It was smaller and 2,000 pounds lighter, with a sharp nose and thinner fuselage. Extra windows improved pilot visibility. The four gas tanks over each engine were replaced by two bigger tanks on top of the fuselage, hidden under the top wing.

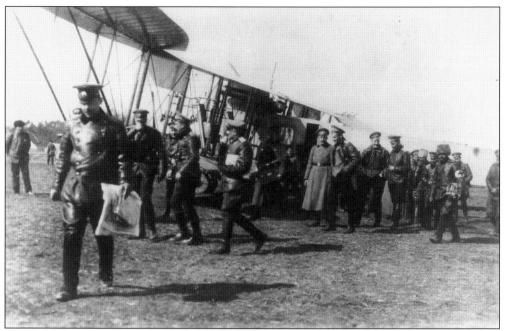

One of the early missions that proved the value of the S-23 Ilya Muromets Beh as a photo-reconnaissance aircraft was flown on March 18, 1915. Capt. G. G. Gorshkov piloted a four-hour flight at an altitude of 11,000 to 12,000 feet, covering about 325 miles. During the mission, 50 photographs were taken of German military installations in East Prussia.

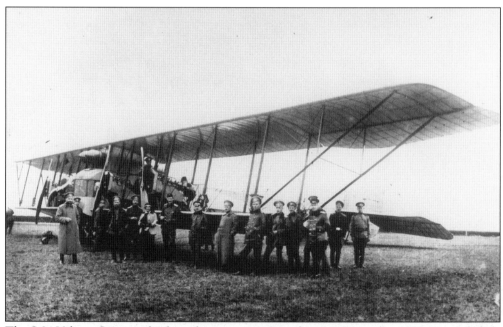

The S-24 Veh, or G-1, was the first of a new series. First flown in December 1915, it was slightly bigger than the earlier Veh. Powered by four 150-horsepower Sunbeam engines, very few were built (perhaps four) as production rapidly shifted to the G-2 variant. In fact, several G-1 airframes on the production line were modified to the G-2 model.

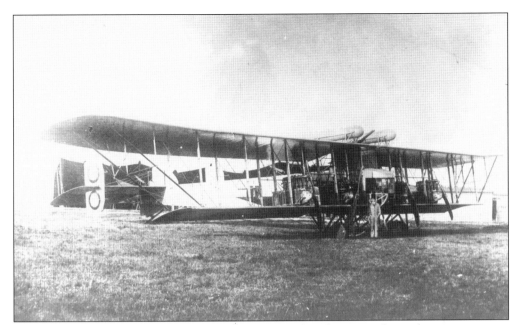

The S-25, or Geh-2, Ilya Muromets was the first aircraft in history with a tail gunner position. First flown in March 1916, about 26 Geh-2s were built before production shifted to the Geh-3. Documents confirm that it flew at altitudes of 17,000 feet on several occasions. Flights were limited by the amount of oxygen bottles on board rather than lack of performance of the aircraft.

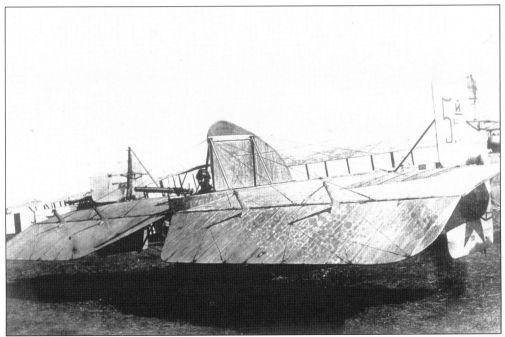

A close-up of a S-25 Geh-2 two-tail gunner's station shows one of the Red Air Force aircraft, judged by the Communist red star on the rudder (far right).

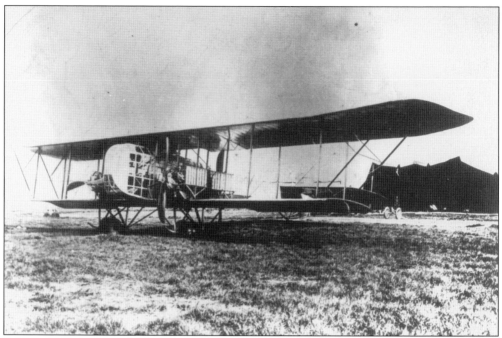

S-26 Ilya Muromets D-1 and D-2 models are pictured here. Smaller than other Ilya Muromets models, the D-1 was powered by four 150-horsepower Sunbeams, arranged back-to-back in the tractor-pusher arrangement. The D-1 was flown twice in late January 1916. According to one source, "The performance was terrible." After the second flight, the D-1 was scrapped.

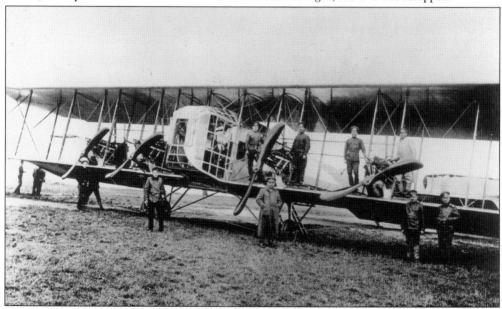

The S-27 Yeh was the largest and heaviest airplane when it first flew in December 1916. Four 220-horsepower Renault engines powered the 16,500-pound gross weight bomber at a cruising speed of 80 miles per hour. The eight-man crew included five gunners for the eight machine gun stations. At least two, possibly four, were built in late 1916. At least one survived the revolution to serve with the Communist air force.

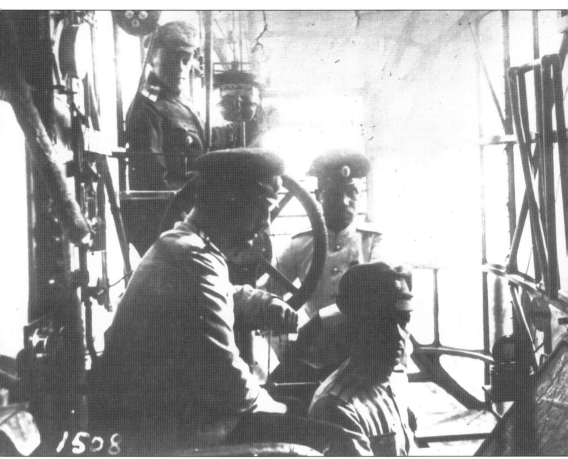

Pictured above is the pilot and crew station of an Ilya Muromets Yeh (S-27) heavy reconnaissance bomber. The pilot is on the left. Note the bench seat for the navigator-nose gunner folded up against right wall. Although blurred, the photograph shows the excellent visibility that the pilot and crew enjoyed.

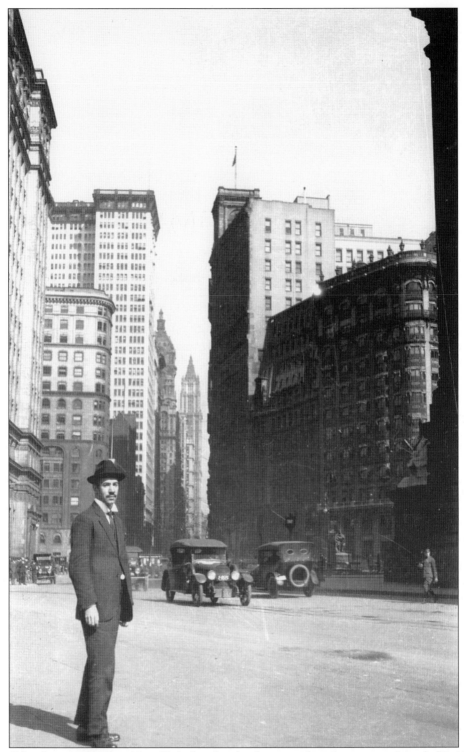

Igor Sikorsky is pictured in New York shortly after his arrival in America on March 30, 1919. Four difficult years later, he was able to resume his aviation career.

Two

A NEW HOMELAND
AND NEW CHALLENGES

On March 30, 1919, Igor Sikorsky arrived in New York with little money, no friends or business contacts, and almost no English-language capability. Many years later, he explained his decision to come to America: "I came to America because I thought this was the place I wanted to make my second mother-land. Here, I found the confirmation of my hopes and came to understand the reason for the success of this great country. It was the free initiative and the free work of a free people."

The first few years were very difficult. The aviation industry had nearly vanished after World War I, unable to compete with surplus "Jenny" training planes selling for $200. After some failed attempts to get restarted in aviation, Sikorsky barely survived by teaching mathematics and physics at a Russian refugee school in New York and lecturing evenings (at $3 to $5) on astronomy and his aviation achievements. As time passed, more and more people urged him to build a new aircraft and even offered to invest modest sums of money in the project.

The catalyst that started Sikorsky in America was Lt. Victor Utgoff, a Russian Navy pilot assigned to the Russian Embassy in Washington, D.C. After the revolution, the embassy closed; Utgoff eventually moved to Long Island, where he had a farm. About 1922, he met Igor Sikorsky. Utgoff encouraged Sikorsky to design a new aircraft and volunteered the use of his farm and his house as Sikorsky's new factory and home. After some hesitation, Igor Sikorsky accepted the generous offer. The two would remain close friends until Utgoff died in a plane crash in 1930; his crucial role in the start of Sikorsky in America is often overlooked.

Thus, on March 5, 1923, about four years after entering America, Igor Sikorsky founded Sikorsky Aero Engineering Corporation. Starting capital was $800 in cash and about $2,000 in pledges. With a small group of Russian volunteers, he built the S-29A (A for America). After a rocky start, the famed composer-pianist Sergei Rachmaninoff invested $5,000 in the company, which helped rent an old hangar on Roosevelt Field to assemble the aircraft. After a crash landing on its first flight, because of underpowered engines, the S-29A was re-engined and proved a success. It earned much-needed money by carrying sightseeing passengers over New York Harbor and charter flights that resulted in valuable publicity. Eventually the S-29A was sold to Roscoe Turner, who later sold it to Howard Hughes, who deliberately crashed it in his epic aviation film, *Hells Angels*.

A series of small prototype aircraft barely kept the company alive during 1924 and 1925. A welcome addition to the company was Michael Gluhareff, a very talented engineer who quickly became Sikorsky's assistant. He would develop very efficient wing-airfoil-flap combinations for

Sikorsky's future long-range aircraft. In 1926, Sikorsky built the S-35 for a famous French World War I fighter ace, who was determined to win the $25,000 Orteig Prize for the first nonstop flight from New York to Paris. The pilot attempted a takeoff in September 1926 that ended in a crash, nearly bankrupting the company. Then, in May 1927, Charles Lindbergh made his famous flight, winning the Orteig Prize, and suddenly the United States became "air-minded." Igor Sikorsky summed up the impact of Lindbergh's flight with these words: "Before his flight, aviation was a hobby . . . after his flight, aviation became a profession."

Aware of the growing market, Sikorsky evaluated the experience gained with two small amphibian prototypes, the S-34 and S-36, and designed a bigger eight-passenger amphibian, the S-38. The calculated performance was so promising that Sikorsky bet the farm by buying engines, propellers, and material to build 10 aircraft in the first production batch. The prototype S-38 first flew in May 1928. It was an instant success and was bought by New York, Rio and Buenos Aires Airlines. The production S-38s were sold in two weeks: three to Pan American Airways, three to Curtis Flying Service (for resale), two to the U.S. Navy, and one each to Western Air Express and Jock Whitney.

The second 10 were sold "off the factory floor." Soon the small company had more business than it could handle. To meet the growing demand, the company moved into a new factory in Stratford, Connecticut, in early 1929. There a new airport and the sheltered waters of Long Island Sound provided the ideal testing grounds for the growing production of the S-38 amphibians. Eventually 114 of these aircraft would be delivered to customers around the world.

In July 1929, in a very friendly merger, Sikorsky Aviation Corporation became a subsidiary of United Aircraft and Transport Company. A family of larger, longer-ranged flying boats soon followed. Among them was the S-40, the first of Pan American Airways' famed Clipper Ships. When completed in 1931, it was the largest aircraft ever built in America, carrying up to 40 passengers across the Caribbean and into South America. In 1934, the S-42 amazed the international aviation community by setting world records for range, payload, and speed considered to be impossible by many aviation experts. As World War II started in 1939, the S-42 had helped to establish Pan American throughout South America and had finished surveying Pan American's transpacific and transatlantic routes.

A flood of military orders for Pratt and Whitney (P&W) engines from England and France resulted in United Aircraft's decision to expand P&W floor space. The quickest solution was to move Chance Vought, another United subsidiary, out of Hartford into the Sikorsky plant. As of April 1939, the merged companies were called Vought-Sikorsky; their products would carry a VS number.

In January 1942, the VS-44 was rolled out. Cruising at 200–210 miles per hour, the flying boat was faster than most land planes of the time. The range was a record-breaking 4,500 miles carrying 16 VIP passengers and 1,600 pounds of mail; up to 38 passengers could be comfortably carried on shorter flights. The VS-44s were used as military transports over the North and South Atlantic during the war years. Of the three built, one survives today in a museum.

Meanwhile, starting in the 1930s, at home and often late into the night, Sikorsky was quietly designing a radically new aircraft.

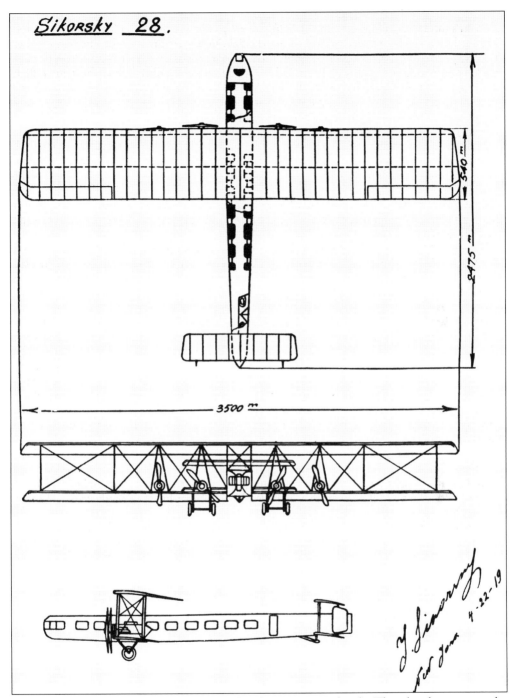

Sikorsky 28.

The S-28 was obviously a civil variant of the Ilya Muromets family. This sketch is among the earliest American designs. It is dated April 22, 1919—about three weeks after Igor Sikorsky's arrival in America.

The S-29A (A for America) is assembled at the Utgoff farm in the spring of 1923. The metal structure was primarily angle iron beams from discarded bedsprings found in city dumps.

Some of the first "volunteers" of the Sikorsky Aero Engineering Corporation are pictured from left to right: unidentified, D. D. "Jimmy" Viner, W. Skorohodoff, A. Samilkin, Baron Soloviev, A. Kotilevtseff, I. Popov, J. Islamoff, Igor Sikorsky, Bob Labensky, V. Ivanoff, Nick Glad, unidentified, A. Krapish, and I. Fursoff.

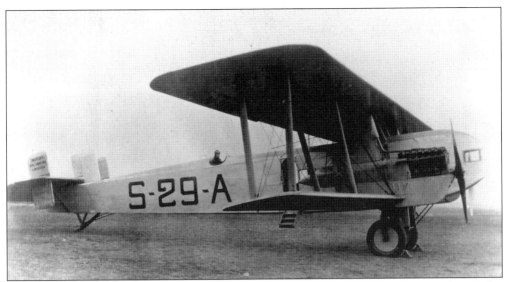

The S-29A was completed in the spring of 1924. Because of the prevailing opinion that a pilot should feel the wind, the pilot sat in an open cockpit. Up to 14 passengers could be carried after the aircraft was re-engined with two 400-horsepower Liberty engines. Note one of the earliest airstair doors in aviation history.

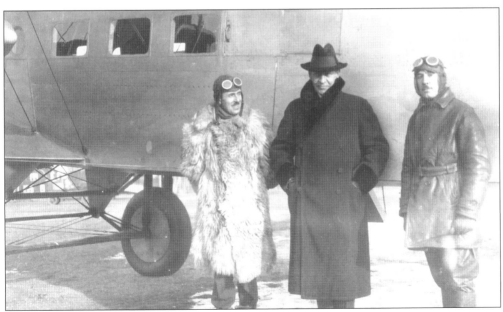

The great composer and pianist Sergei Rachmaninoff stands in front of the S-29A, flanked by Baron Soloviev (left) and Sikorsky. At the time, it was the largest aircraft ever built in America, with a wingspan of 69 feet and a gross weight of 12,000 pounds.

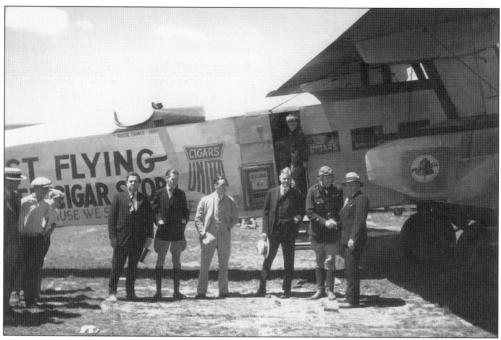

Barnstormer and racing pilot Roscoe Turner leased and later purchased the S-29A from Igor Sikorsky in early 1926. For two years, he flew it for a variety of customers, such as the United Cigar Company, Macy's, Curlee Clothing, and others. Roscoe's monthly lease payments helped keep the Sikorsky factory alive.

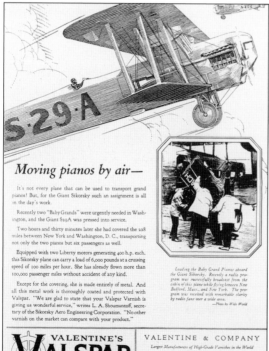

One of the first charter flights for the S-29A was to carry two baby grand pianos from New York to Washington, D.C. The flight earned Sikorsky $500 and much valuable publicity as shown by the vintage advertisement by the Valspar Company.

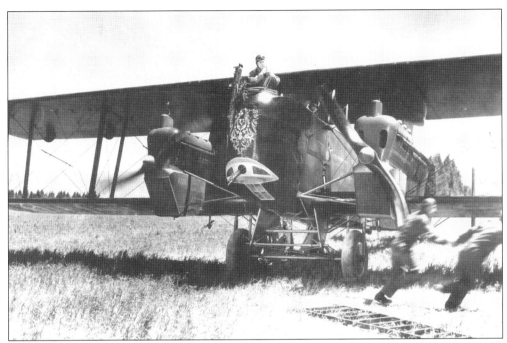

In February 1928, Roscoe Turned flew the S-29A to California, where Howard Hughes bought the aircraft. It was cosmetically changed to look like a World War I German Gotha bomber and played a major role in Hughes's aviation epic, *Hells Angels*. It was deliberately crashed for the film in March 1929.

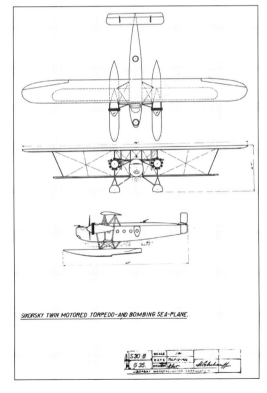

SIKORSKY TWIN MOTORED TORPEDO-AND BOMBING SEA-PLANE.

The S-30 was designed as a light military bomber or commercial transport. Although the aircraft was never built, many of the design details were incorporated in the S-35.

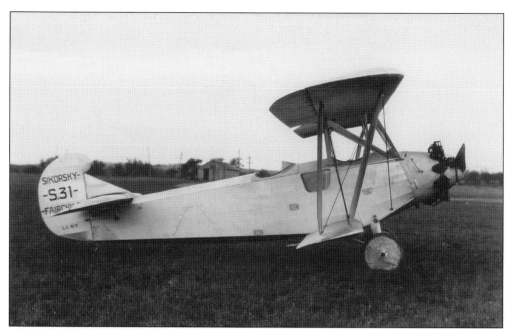

The S-31 was built for the Fairchild Company for aerial mapping and photography in South America. Powered by 200-horsepower Wright J-4 Whirlwind engines, it could carry up to four passengers in the forward cockpit and semi-enclosed cabin between the two cockpits. A generous 45-foot wingspan allowed flights at altitudes of 12,000 to 15,000 feet.

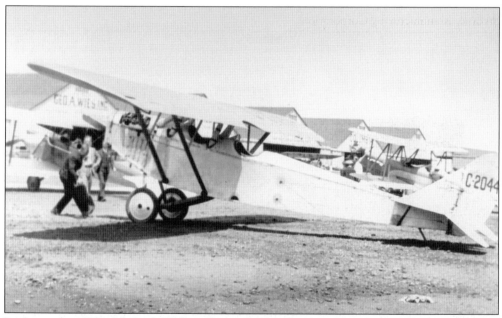

In September 1924, Michael Gluhareff joined Sikorsky Aero Engineering Corporation as a draftsman. His wing design for the Curtis Oriole and Jenny aircraft showed far higher cruise speeds and lower landing speeds, which resulted in some 20 biplane and monoplane wings being sold. A monoplane Jenny conversion (C-2044) is shown above at Roosevelt Field, Long Island, New York.

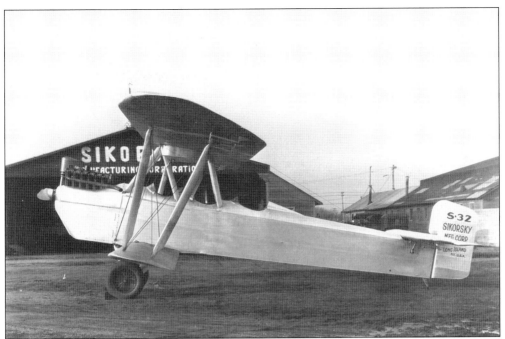

One S-32 was built in 1926 for a subsidiary of the Standard Oil Company and was used extensively in Colombia. Powered by a 400-horsepower Liberty engine, it had a wingspan of 58 feet. Two pairs of passengers sat in the two front cockpits. The pilot sat in the rearmost cockpit. Most of its life was spent on floats. In July 1925, the company changed its name to Sikorsky Manufacturing Corporation.

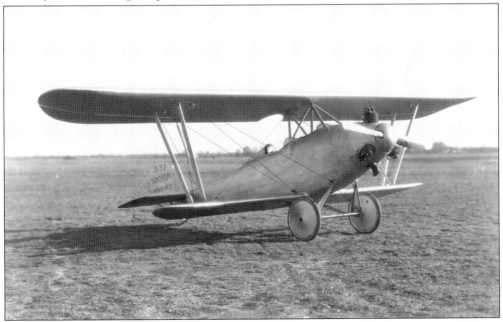

The S-33 was first built as a racing aircraft with a 60-horsepower Wright engine in 1926. A second S-33 was built in 1927 in a two-seat configuration powered by a 60-horsepower Lawrence engine. The S-33 had a wingspan of 32 feet and could reach a speed of 103 miles per hour.

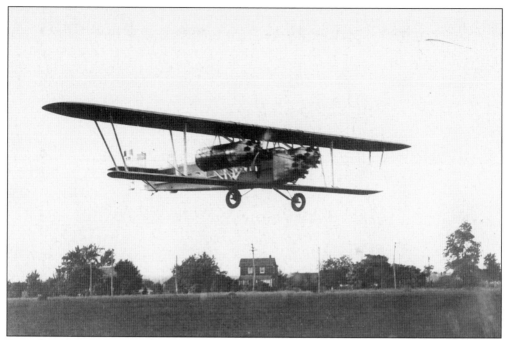

In early 1926, work started on a new twin-engine aircraft to replace the S-29. It attracted French World War I ace Rene Fonck, who persuaded Igor Sikorsky to redesign the S-35 into a three-engine long-range aircraft to win the Orteig Prize for the first nonstop flight between New York and Paris. Initial flight tests in August 1926 were highly successful. It was powered by three 420-horsepower Gnome-Rhone engines.

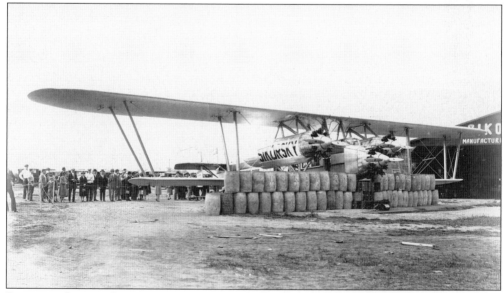

Determined to win the Orteig Prize before the onset of winter, Fonck fueled the S-35 and waited for a break in the weather. At dawn on September 21, 1926, the aircraft began its takeoff run, but the auxiliary landing gear broke. The aircraft never left the ground and crashed into a ravine at the end of the field. Fonck and his copilot Lt. William Curtin, USN, survived; two crew members died.

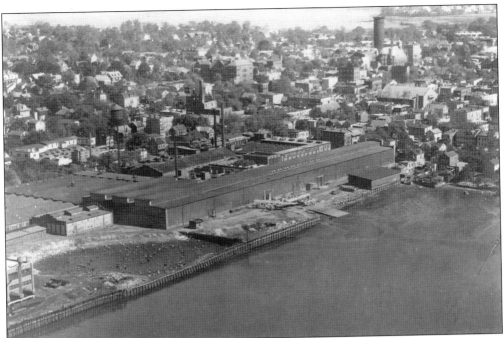

Impressed by the S-35's potential, Fonck ordered a new long-range aircraft to win the Orteig Prize. To build the aircraft, part of the factory building at College Point, Long Island, New York, was rented in the summer of 1926. As work started on the S-37, an earlier project was completed.

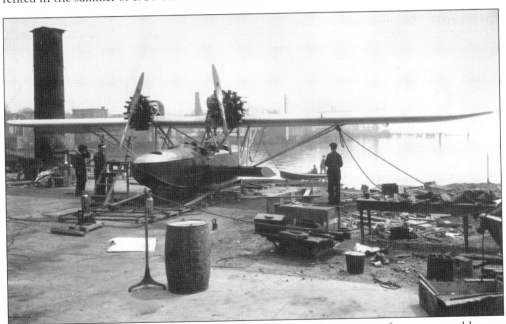

In 1926, Sikorsky built his first amphibian: the S-34. The six-seat aircraft was powered by two 200-horsepower Wright engines. Its brief life ended when mechanical problems resulted in a forced landing on the water. The pilot, Captain Collier, and observer, Sikorsky, were rescued by a nearby motorboat. The damaged S-34 sank. The S-34 is shown here on the newly rented College Point facility.

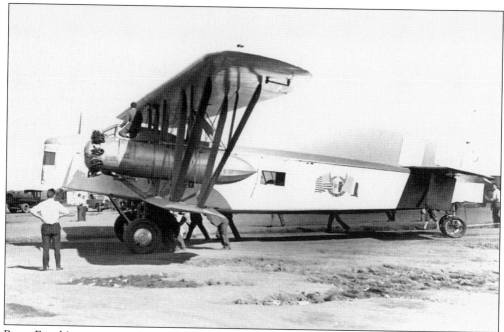

Rene Fonck's new transatlantic aircraft was the S-37. Powered by two 500-horsepower Jupiter engines, it had a wingspan of 100 feet and a potential range of 4,000 miles at a cruising speed of 120 miles per hour. When Charles Lindbergh won the Orteig Prize in May 1927, Fonck's backers sold the S-37. It became the first commercial transport between Buenos Aires and Santiago, regularly crossing the 19,000-foot Andes Mountains.

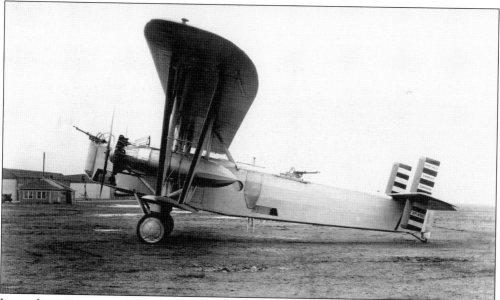

Later that same year (1927), a second S-37 was jointly built by Sikorsky and Consolidated Aircraft. It was designed as a bomber. When the U.S. Army Air Corps showed no interest, it too was converted into a 20-passenger commercial aircraft and sold to a South American airline competing with Pan American: New York, Rio and Buenos Aires Airlines or NYRBA (better known as "Near Beer").

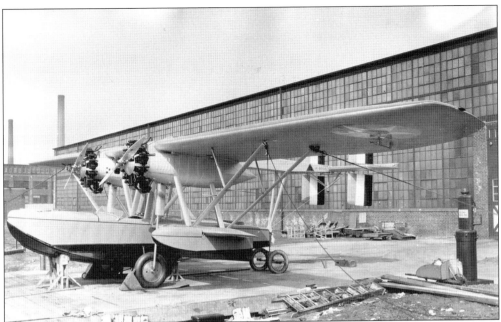

The prototype S-36 was an improved S-34, with two 200-horsepower Wright engines. It retained the three open cockpits of the earlier S-34. Built in 1927, it was purchased by the U.S. Navy and operated as the XPS-1. The wing was designed so that the span could be increased from 62 to 72 feet for long-range missions.

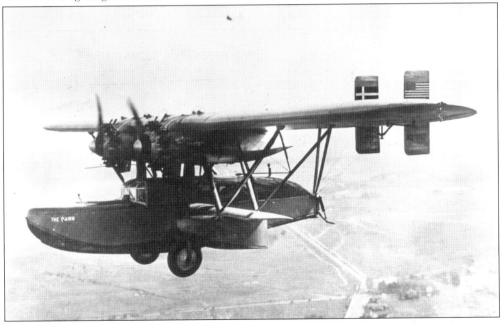

Five production S-36 aircraft were built. Two were bought by the U.S. Navy, two by Pan American Airways, and one by Frances Greyson, a niece of Pres. Woodrow Wilson. She named the aircraft the *Dawn*. Determined to be the first woman to fly the Atlantic, she hired two pilots for the trip. Despite warnings, the *Dawn* took off in December 1927 and vanished without trace over the Atlantic.

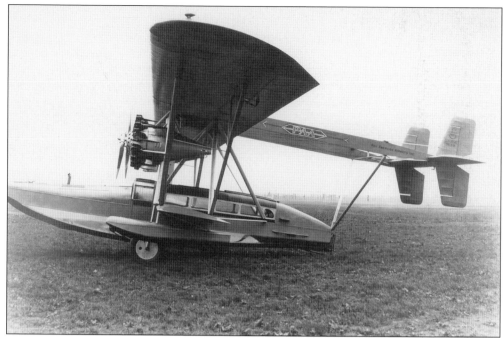

The prototype S-38A was certified in June 1928 and immediately sold to NYRBA. The Pan American Airways markings date the photograph as "sometime after September 1930" when Pan American took over the aircraft and routes of NYRBA. The aircraft was scrapped after being damaged while landing in San Juan in August 1931.

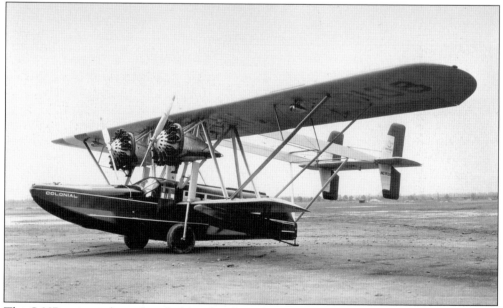

The S-38B series is best identified by the slanted cockpit windshield, which is seen here on S-38 No. 21 (NC-9138). It was delivered to Colonial Western Airlines in mid-1929. After a number of owners, it was sold to the Bol-Inca Company in Bolivia in 1935. Most S-38s were powered by P&W Wasps at 420 horsepower. A few were delivered with 500-horsepower Hornets and Cyclones.

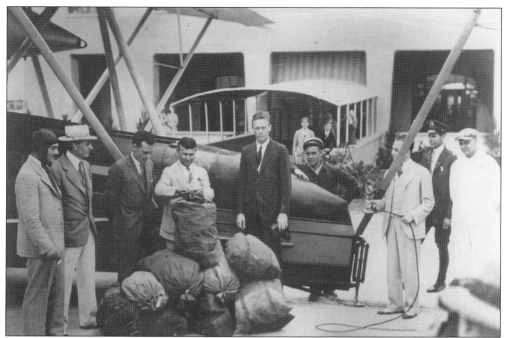

In February 1929, Charles Lindbergh flew Pan American's first airmail flight from Miami to Cristobal, Panama Canal, and back to Miami. This began a series of Caribbean goodwill flights by Lindbergh and Pan American Airways president Juan Trippe that secured valuable landing rights across the Caribbean and into South America.

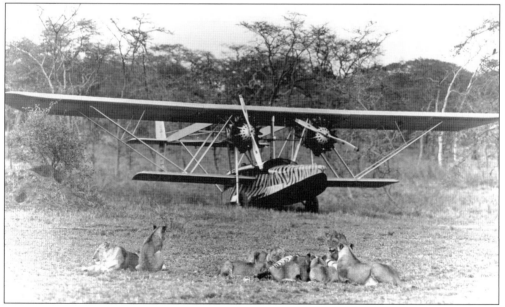

In 1933 and 1934, famed African explorers Martin and Osa Johnson used an S-38 and S-39 to explore and film remote parts of Africa. The *Flying Safari* covered more than 60,000 miles, much of it uncharted territory. In this photograph, Osa Johnson can be barely seen as she peeks at the lions from the rear hatch of the S-38. The wingtip floats have been removed to reduce weight and drag.

49

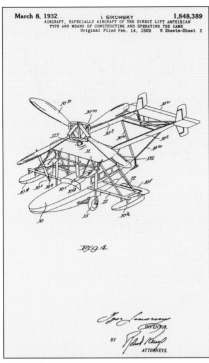

March 8, 1932. I. SIKORSKY 1,848,389
AIRCRAFT, ESPECIALLY AIRCRAFT OF THE DIRECT LIFT AMPHIBIAN
TYPE AND MEANS OF CONSTRUCTING AND OPERATING THE SAME
Original Filed Feb. 14, 1929 8 Sheets-Sheet 2

Igor Sikorsky's continued interest in rotary-wing aircraft is shown in a patent application dated February 14, 1929. Obviously based on the S-38, it seems to be a study of how to convert the S-38 into an autogyro.

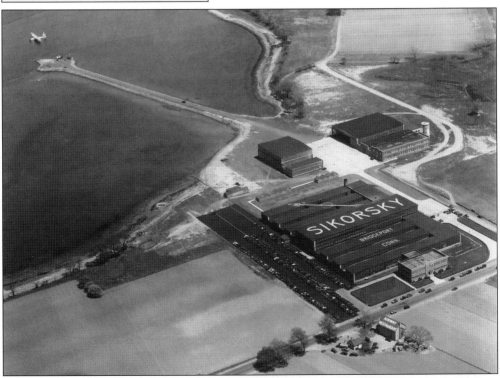

With new capital, Sikorsky purchased land in Stratford, Connecticut, near Bridgeport in close proximity to Long Island Sound's ample water area, which was very important for development of larger seaplanes. The photograph above shows the completed facility in the mid-1930s.

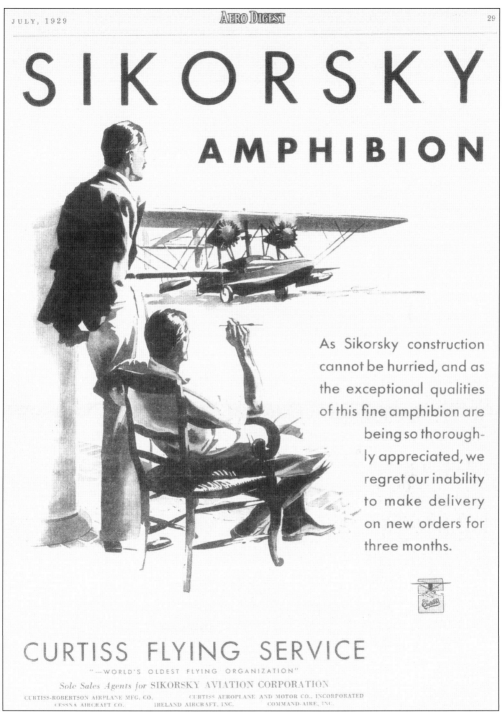

SIKORSKY

AMPHIBION

As Sikorsky construction cannot be hurried, and as the exceptional qualities of this fine amphibion are being so thoroughly appreciated, we regret our inability to make delivery on new orders for three months.

CURTISS FLYING SERVICE

"—WORLD'S OLDEST FLYING ORGANIZATION"

Sole Sales Agents for SIKORSKY AVIATION CORPORATION

CURTISS-ROBERTSON AIRPLANE MFG. CO. CURTISS AEROPLANE AND MOTOR CO., INCORPORATED

CESSNA AIRCRAFT CO. IRELAND AIRCRAFT, INC. COMMAND-AIRE, INC.

This nostalgic advertisement was one of Sikorsky's favorites and hung in a corner of his office until his death. It was published in July 1929 in the venerable *Aero Digest* as Sikorsky Aviation became a subsidiary of United Aircraft and Transportation Company. Sikorsky wanted his flying amphibian spelled another way, but *Webster's Dictionary* won the battle.

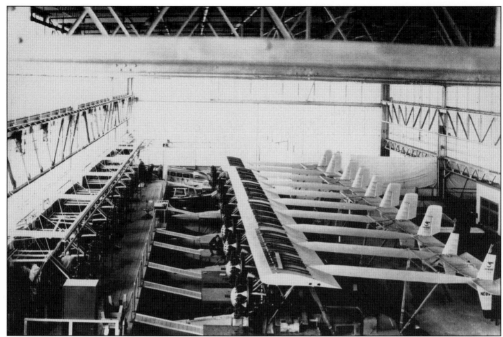

The success of the S-38 justified the building of a new dedicated manufacturing plant in Stratford. The first Stratford-built S-38 was delivered to NYRBA in November 1929; the last four College Point, New York, S-38s were delivered in mid-December 1929. In all, about 114 were built. No original S-38s survive, but two excellent replica S-38s are currently on flight status.

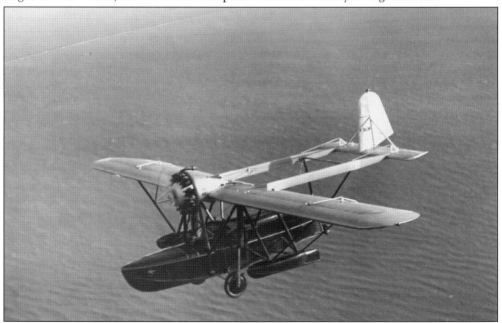

In 1930, Igor Sikorsky built a small amphibian, the four-to-five-seat S-39. It was powered by a 300-horsepower P&W Wasp Jr. engine. About 21 were built and flown as newspaper-photo planes and by private owners. One was used by Martin and Osa Johnson in their African and Borneo expeditions. One restored S-39 is still flying, as of 2006.

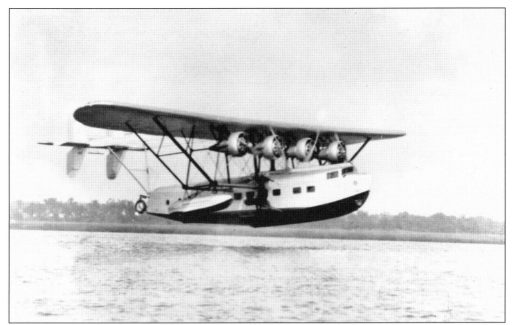

The first flight of the S-40 was on August 7, 1931. Weighing just over 34,000 pounds, it was capable of carrying up to 40 passengers over a range of 500 to 900 miles, depending on the load. After being christened the *American Clipper* by Pres. Herbert Hoover's wife, the S-40 was flown (in short hops for maximum publicity) on its inaugural flight. On the return flight, Charles Lindbergh and Sikorsky began to sketch a new transoceanic airliner. This was in November 1931.

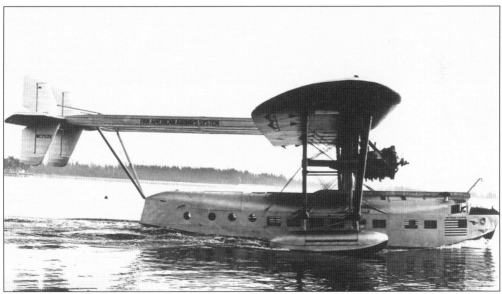

In 1935, the three S-40s had the landing gear removed, thus saving some 1,200 pounds, and higher-powered 660-horsepower P&W Hornet engines were installed. After flying more than 10 million miles without incident, they were retired from passenger service in 1940. Following Pearl Harbor, the aircraft flew as trainers and cargo carriers for the U.S. Navy. Note the large cargo hatch outline atop the rear fuselage of the NC-752V *Southern Clipper*.

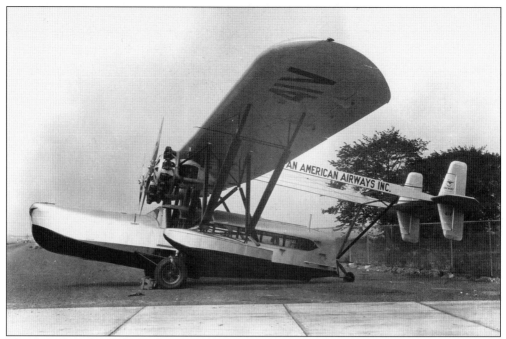

The S-41 (1930) was basically a larger S-38, carrying 12 to 14 passengers. Powered by two 575-horsepower P&W Hornet engines, it cruised at about 120 miles per hour. Seven were built. Three were sold to the U.S. Navy as RS-1s, and three were sold to Pan American Airways, which used them in the Caribbean, then assigned two to its short-lived Boston-Bangor-Halifax Airline. Pictured here is 41V, which crashed in Massachusetts Bay in 1931.

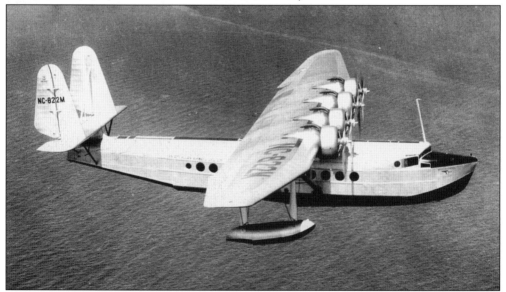

The aircraft that Charles Lindbergh and Igor Sikorsky sketched out during the S-40's inaugural flight to the Panama Canal in 1931 became the S-42. It first flew in March 1934. The S-42 entered service with Pan American Airways in 1934; it cut the trip from Miami to Rio de Janeiro from seven days to five days. It carried up to 32 passengers 600 to 1,000 miles at a cruising speed of 155 to 160 miles per hour.

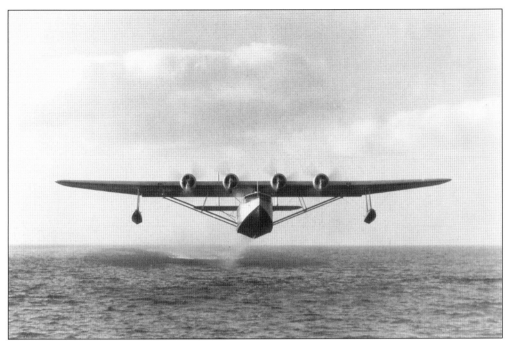

One of the secrets to the success of the S-42 was the wing design by Michael Gluhareff. The four P&W 700- to 750-horsepower Hornet engines were hidden in streamlined cowlings in the thin, graceful wing. By 1937, specially equipped S-42s had completed the transpacific and transatlantic survey flights for Pan American Airways.

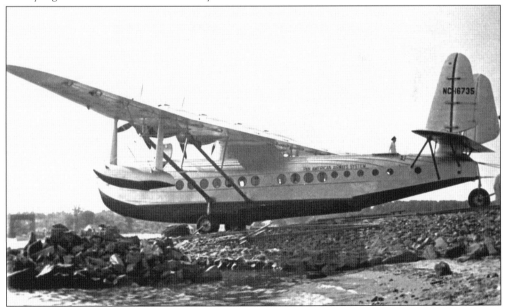

Sikorsky's S-42B was registered in the summer of 1936 as NC16735 and was delivered to Pan American Airways in September 1936. It was first named *Bermuda Clipper* and used on the Baltimore-Bermuda service; then it was used briefly in Alaska in 1940 as the *Alaska Clipper*. Following that, it was renamed the *Hong Kong Clipper II*. It was assigned to the Manila–Hong Kong service in early 1941. It was destroyed by Japanese aircraft on December 8, 1941.

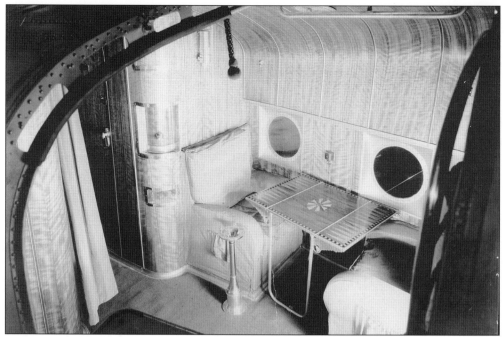

Two deeply cushioned chairs and a folding backgammon table greeted the passengers as they boarded the S-42. The wood-paneled passageway led past the toilet compartment to a series of cabins. Hot meals were served in flight by uniformed stewards. Toward evening, the Clipper would land in a major harbor, and the passengers would overnight in a luxury hotel, courtesy of Pan American Airways.

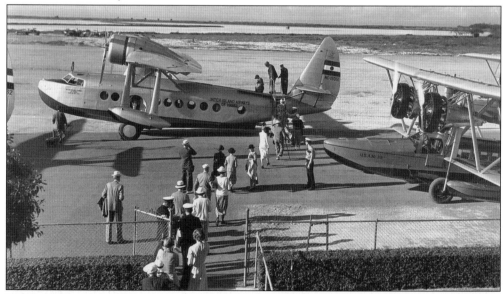

The first flight of the S-43 amphibian was on June 1, 1935. Powered by two 750-horsepower P&W Hornet engines, it carried 15 passengers at 165 miles per hour and had a range of 750 miles. The first customer was Hawaii's Inter Island Airways, which would eventually operate four of them. Often called the "Baby Clipper," it was flown in the Americas, Europe, Africa, and the Far East. A total of 53 were built.

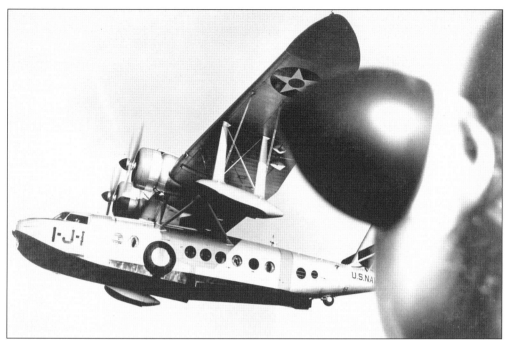

The U.S. Navy bought 17 S-43s in 1937 and 1938, designating them the JRS-1. The U.S. Army Air Corps bought five in 1937 designated the X10A-8. Several JRS-1 aircraft were at Pearl Harbor on December 7, 1941. One survived the devastating Japanese attack and was the first American aircraft to take off and hunt for the Japanese fleet. The same aircraft is stored by the National Air and Space Museum awaiting restoration.

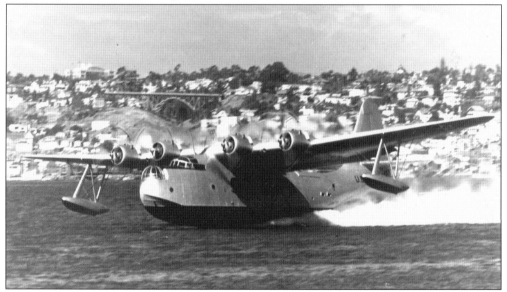

The Sikorsky XPBS-1 long-range patrol bomber first flew on August 13, 1937. It was well armed, with two .50-caliber machine gun turrets, as well as two .30-caliber waist guns. With four 1,050-horsepower P&W Wasp engines neatly cowled in the 124-foot wing, the aircraft had a maximum range of 4,000 miles. Although superior in performance, it lost to a lower-priced competitor.

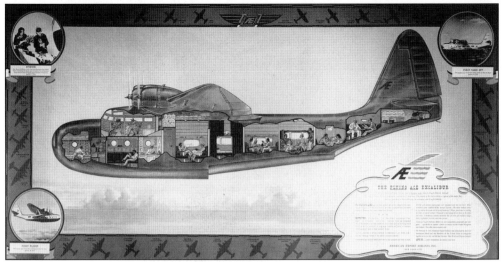

In 1937, the American Export Steamship Line created a subsidiary, American Export Airlines, which ordered three civil versions of the XPBS-1. The first VS-44 flew in January 1942. Powered by four 1,200-horsepower Twin Wasp engines, it carried 16 passengers in VIP comfort (including full-length beds) over 4,000 miles at a cruise speed of 160 miles per hour. Thirty-eight passengers could be carried on shorter flights.

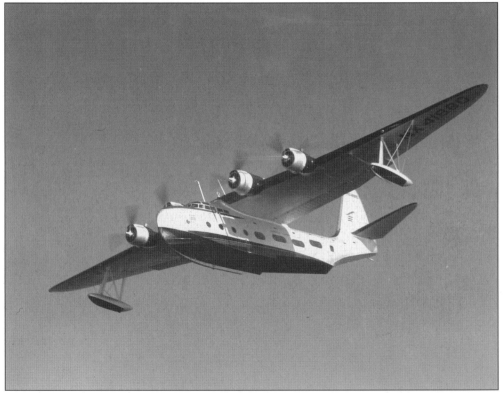

The *Excalibur* (N-41880) was the first of three VS-44s built for American Export Airlines. Here it is photographed, still in its civil paint scheme, during a test flight in the spring of 1942. The *Excambian* (N-41881) and the *Exeter* (N-41882) were put into service later that same year.

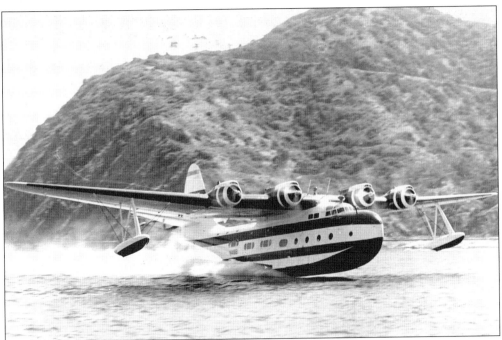

The *Excambian* flew charters in South America and then flew for Avalon Air Transport in California and Antilles Air Boats in St. Thomas. Damaged beyond repair in a landing accident, it was eventually restored by a group of Sikorsky volunteers and is now in the New England Air Museum. In the photograph, the *Excambian* is seen on a takeoff with Catalina Island in the background.

In his 1935 speech before the Royal Aeronautical Society, Igor Sikorsky described a giant 100-passenger flying boat of the future, allowing nonstop flights between New York and London and Paris. By 1938, the design had matured to the point that it was designated the S-45. The project was terminated on the eve of a new world war and the appearance of the first four-engined long-range land planes.

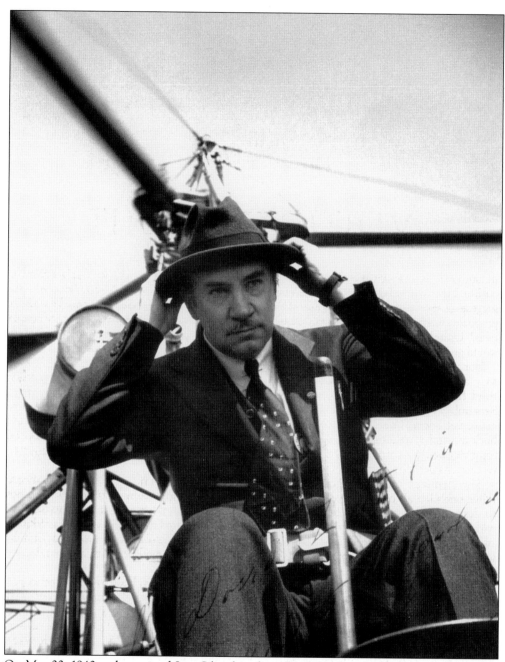

On May 20, 1940, a determined Igor Sikorsky adjusts his legendary "crash helmet" fedora just before takeoff. This would be the first public demonstration of the VS-300 helicopter to a small group of aviation writers and invited guests. All were fascinated as he lifted straight up into the air, hovered motionless overhead at an altitude of 30 feet, and then proceeded with his flight display. (Courtesy of Prof. R. G. Loewy.)

Three

VERTICAL FLIGHT

In late 1938, in a historic meeting with the management of (then) United Aircraft, Igor Sikorsky outlined the technology of a radically new machine he proposed to build—a helicopter. After suggesting several potential missions for the new aircraft, Sikorsky ended his remarks with the prophetic words "the helicopter will prove to be a unique instrument for the saving of human lives." United Aircraft management approved the project, probably unaware that the decision would give birth to a new industry.

Igor Sikorsky and a small team of his closest associates designed the VS-1 in early 1939. In May, as construction started, the designation was changed from VS-1 to VS-300. Igor Sikorsky's third helicopter, built 30 years after his first two machines, first "hopped" into the air on September 14, 1939. It was a simple open framework of welded steel tubing, ending in a sheet metal tail boom. This concept allowed overnight changes to the structure, with the help of a hacksaw and a welding torch. The 75-horsepower Lycoming engine drove the main and tail rotor through belts and pulleys that could be easily changed to modify the ratio and, thus, rotor revolutions per minute, and tail rotor location, as desired.

The challenge was best described in Sikorsky's own words: "The VS-300 was a chance to relive one's life all over again. To design a new type of flying machine without knowing how to design it; then build it without really knowing how to build it and then try to test-fly it without ever having flown a helicopter before." Sikorsky accepted the challenge. In the following two years, he taught himself how to fly the VS-300, while testing and evaluating roughly four major configurations, untold dozens of design and control modifications, and hundreds of minor changes.

However, in December 1941, as America went to war, the VS-300 had proven the concept of the single–main rotor helicopter and anti-torque tail rotor. (Interestingly over 95 percent of the world's helicopters manufactured since then use the same single-main rotor concept perfected by Igor Sikorsky.) Based on the VS-300 technology, the U.S. Army ordered a prototype two-seat training helicopter, the XR-4. It was delivered in May 1942. After testing, orders were placed for a total of 133 R-4s, of which eight were for Great Britain. In addition, the U.S. Army placed orders for two larger prototypes, the XR-5 and XR-6. In January 1943, Great Britain surprised the skeptics by ordering 200 more R-4s.

With both partners needing more manufacturing space, the Vought-Sikorsky merger was dissolved in January 1943. Production of the fixed-wing Corsair, Kingfisher, and other Vought programs continued in the original Sikorsky plant in Stratford. Sikorsky Aircraft moved "across town" to a factory in Bridgeport, Connecticut. By the fall of 1943, the first R-4s were being delivered, and both the XR-5 and XR-6 prototypes were in flight-test programs.

In 1944, two pilots would start the proud history of saving lives by helicopter.

That January, a Coast Guard HNS-1 (R-4) piloted by Lt. Comdr. Frank Erickson flew blood plasma through a sleet storm that had closed all airports between Baltimore and Boston to the burned survivors of the destroyer USS *Turner* after it exploded off New York Harbor. It was the first lifesaving mission by helicopter. In April 1944, U.S. Army lieutenant Carter Harman made the first combat rescue flights when he flew his R-4 four times through Japanese-held Burma to evacuate four Allied soldiers after their aircraft crashed in the jungle.

With the end of World War II, all military helicopter programs, including those at Sikorsky Aircraft, were reduced or cancelled. However, Sikorsky had delivered about 65 two-seat military R-5s and the basic design had matured. The cabin was widened to allow for a three-seat bench behind the pilot. The modified four-place R-5 became the civil S-51. The enlarged cabin proved popular. More than 200 commercial and military S-51s were sold in the postwar years. Another 137 were built under license by Westland Aircraft of Great Britain.

The Korean War, which started in June 1950, proved the S-51 (R-5) was a versatile transport vehicle with great lifesaving potential. Sikorsky recalled that the first GI nickname for the machine was the "Infuriated Palm Tree." It soon changed to the "Guardian Angel." By the end of the war, helicopters had saved the lives of at least 10,000 critically wounded soldiers and had also rescued more than 1,200 Allied personnel from behind enemy lines.

As a result of the Korean War, helicopters began to grow in size, in capacity, and in versatility. The military use of the helicopter expanded as new missions were tested and approved. In the mid-1950s, the appearance of jet turbine engines specifically designed for helicopters led to a new generation of rotary-winged aircraft with greatly improved performance over the older piston-engined machines. A number of helicopter designs developed for military use were modified into commercial transports. These helicopters created new uses, such as transporting work crews to offshore oil rigs; specialized medical and trauma transport helicopters appeared and helicopter airlines and corporate helicopters began a slow but steady growth.

Igor Sikorsky formally retired from Sikorsky Aircraft in May 1957 at the age of 68. He helped guide the design of the S-61, which first flew in March 1959. The S-61 was so far ahead of its time that it was built under license by Westland in England, Agusta in Italy, and Mitsubishi in Japan. Hundreds of S-61s are still flying today, nearly 50 years after the prototype first flew.

Igor Sikorsky's last personal project was the S-60 Flying Crane, which flew in January 1958, demonstrating the advantages of precise hovering with the help of a rearward-facing pilot station. This led to the design of a much more powerful crane, the S-64, which first flew in May 1962. Many cranes served in Vietnam and Europe. Today a growing number are being rebuilt into commercial heavy lifters and are used for construction, firefighting in rugged terrain around the world, and many tasks thought impossible not that long ago.

Igor Sikorsky continued as a consultant to Sikorsky Aircraft through the 1960s and into the 1970s. He passed away in his sleep on October 26, 1972. He left a legacy as an engineer, as a pilot, as a visionary pioneer, and as a remarkable human being. He was proudest of the fact that the helicopter that he helped create became "a unique instrument for the saving of human lives." His life and his legacy continue to be a source of inspiration for all those who carry on his work.

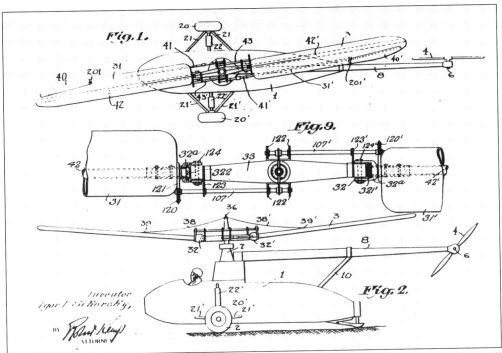

Igor Sikorsky's patent application of June 27, 1931, describes a single-rotor helicopter with a small torque compensating tail rotor. The same configuration is seen seven years later in the VS-300.

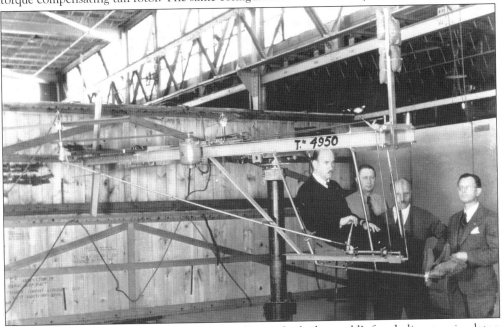

In the fall of 1938, Igor Sikorsky and his small team built the world's first helicopter simulator. The test rig No. 4950 had three two-bladed rotors driven by a five-horsepower electric motor. The vertical rotor simulated the anti-torque tail rotor; the two horizontal rotors provided pitch and roll control. The photograph shows Sikorsky in the trainer. Behind him from left to right are Michael Buivid, Bob Labensky, and Michael Gluhareff.

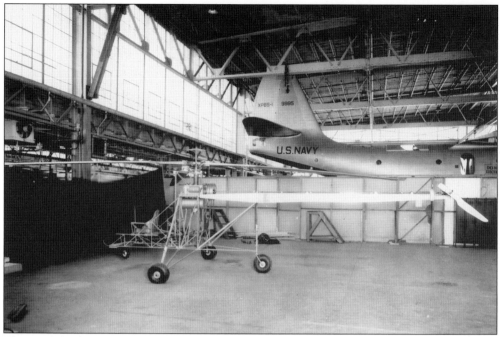

The partly built VS-300 was photographed on September 8, 1939, with the XPBS-1 Flying Boat in the background. The three-bladed main rotor and single-bladed tail rotor are in place, while the 75-horsepower Lycoming engine had yet to be installed. Note the pilot's seat that seems to be from a World War I Curtiss Jenny.

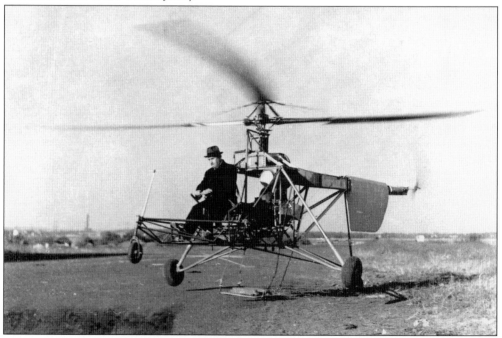

The first "flight" of the VS-300 was on September 14, 1939. It reached an altitude of eight inches off the ground and a duration of possibly 10 seconds and was the start of a two-year test and development program. This was the configuration up to the rollover crash of December 9, 1939.

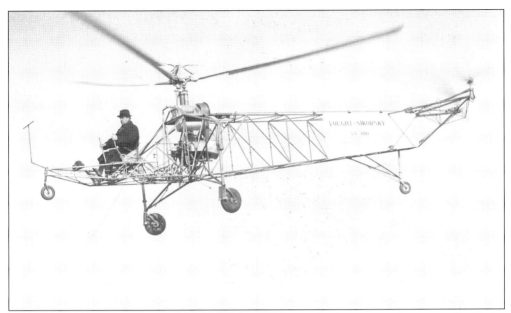

Following the December 9 rollover, the VS-300 was rebuilt into configuration II. Cyclic (directional) control was removed from the main rotor, leaving only collective (up-down) control. The tail was rebuilt with one vertical rotor and two horizontal rotors for pitch and roll control. It was basically the same as the flight simulator. The first flight on March 6, 1940, showed improvement in control and stability.

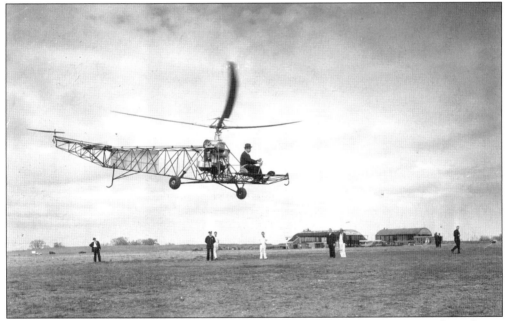

Igor Sikorsky flew the first public demonstration of the helicopter on May 20, 1940. The audience of reporters and cameramen was joined by the senior management of United Aircraft. The demonstration generated much favorable comment in the press, as well as among the spectators. Sikorsky was asked why he had not demonstrated forward flight; he answered, "This is a minor technical problem that we have not solved yet."

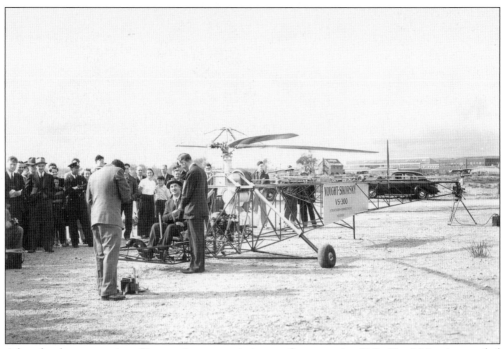

After the demonstration, Connecticut commissioner of aeronautics C. L. "Les" Morris awarded Igor Sikorsky Connecticut helicopter license No. 1.

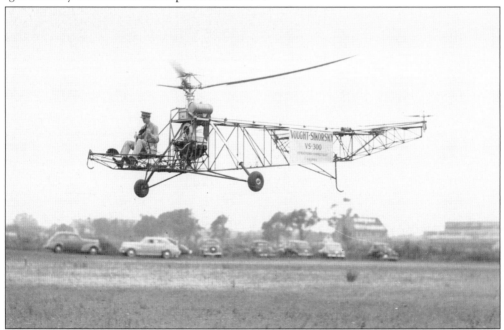

In June 1940, improved tail rotor blades were installed. In July, a new 100-horsepower Franklin engine with improved performance was installed. On July 24, the VS-300 was flown by Capt. H. Franklin (Frank) Gregory, U.S. Army Air Corps, and Capt. Vic Haugen, his assistant. Both would become strong supporters of the helicopter. Here Captain Gregory hovers in the VS-300 on his first flight.

During the development of the VS-300, Charles Lindbergh was a frequent visitor. Later he flew the VS-300 himself. He is pictured here with Sikorsky (left) on October 9, 1940, and was a witness when, that day, the VS-300 established an altitude record of 100 feet.

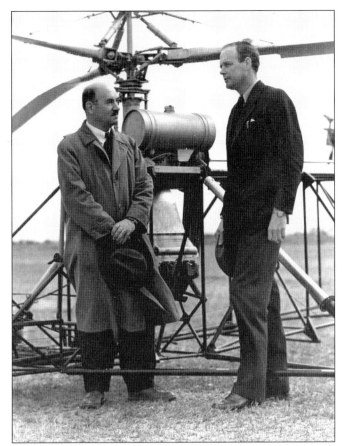

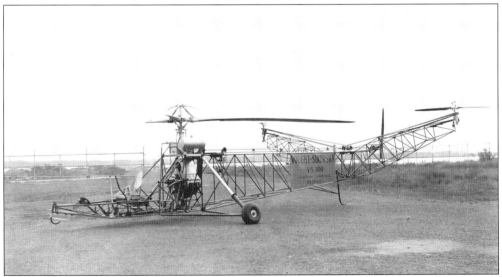

Through the fall and winter of 1940, a variety of horizontal tail rotor positions were tested. The fatigue failure of the left tail boom led to a crash on October 14, but Sikorsky was unhurt. Quickly repaired and with many modifications to the control system, as well as a new 28-foot rotor, the VS-300 was back in the air on December 24, 1940.

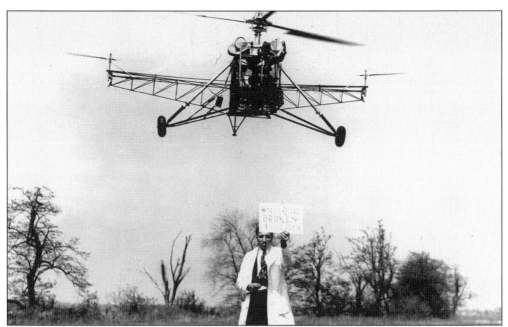

During the spring of 1941, the VS-300's horizontal tail rotors were adjusted and moved several times. Performance improved, but a wobble at forward speeds was still there. In April, an American helicopter endurance of one hour and five minutes was established. On May 6, 1941, Igor Sikorsky set a new world record of 1 hour 32 minutes. In the photograph above, Bob Mackellar holds up a sign to announce the new record.

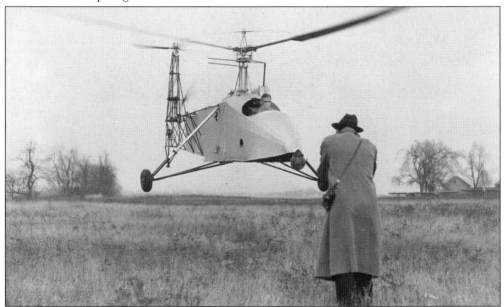

In midsummer 1941, it was decided to return to full cyclic control in two steps. The two horizontal rotors were replaced with one horizontal rotor on a tower to provide pitch control. Lateral (side-to-side) control was provided by cyclic control of the main rotor. Here Sikorsky photographs "attitude sticks" fixed to the main rotor swashplate. The pilot is Les Morris, who had become a Sikorsky test pilot. The date is November 19, 1941.

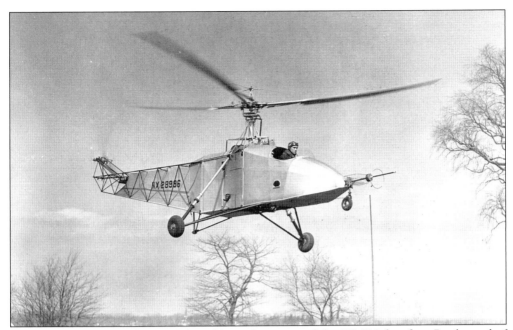

On December 8, 1941, the final (fourth) configuration of the VS-300 first flew. By the end of December, with lead-lag dampers and streamlined covering, it was a mature and successful prototype. The photograph above, taken on March 6, 1942, shows Les Morris spearing a ring during a demonstration of precision control.

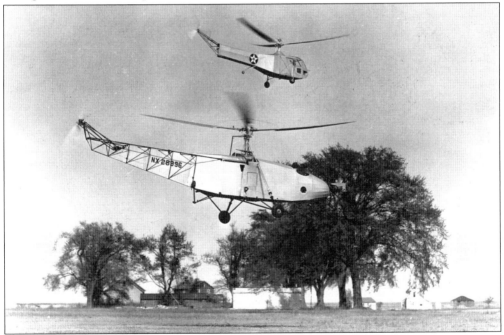

The two-place XR-4 first flew on January 13, 1942. It was first shown to a small group of senior military and civilian officials on April 20, 1942. In this photograph of the event, Igor Sikorsky flies the VS-300, nearest the camera, and Morris flies the prototype XR-4 in the background. In May, the XR-4 flew to Wright Field in Dayton, Ohio, with Morris at the controls.

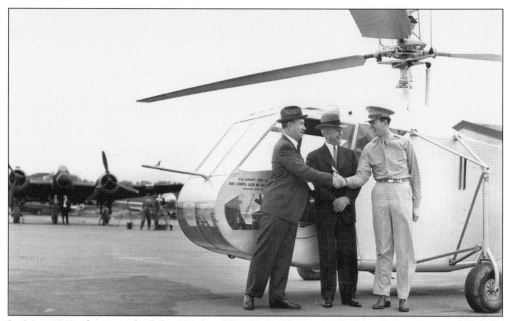

In May 1942, the arrival of the XR-4 at Wright Field was marked by the presence of Orville Wright, the first man to pilot a flying machine. Here Igor Sikorsky and Lt. Col. Frank Gregory, USAAF, shake hands with a beaming Orville Wright in the middle. Eventually 131 R-4s would be delivered to U.S. and British forces.

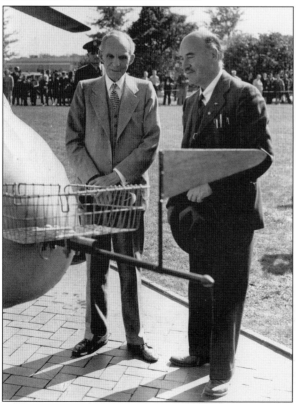

The VS-300 remained active, testing a variety of main and tail blade designs, and training several future Sikorsky test pilots and VIP visitors such as Charles Lindbergh. On October 6, 1943, the VS-300 was given to the Ford Museum. In its four years, it flew a total of 102 hours and 35 minutes. Here Henry Ford (left) smiles as Igor Sikorsky says, "she was a good ship . . . a sweet little ship."

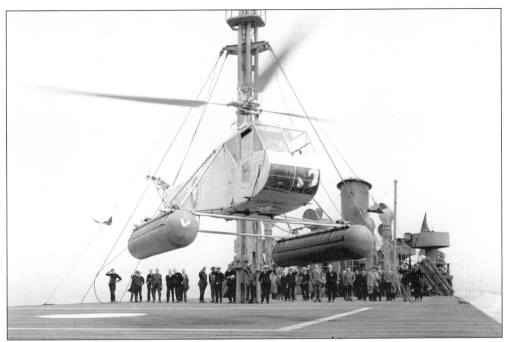

On May 6 and 7, 1943, Colonel Gregory made a series of landings aboard the SS *Bunker Hill*. The tanker had an improvised 60X70 foot platform midships, which Colonel Gregory used to demonstrate 23 landings and takeoffs.

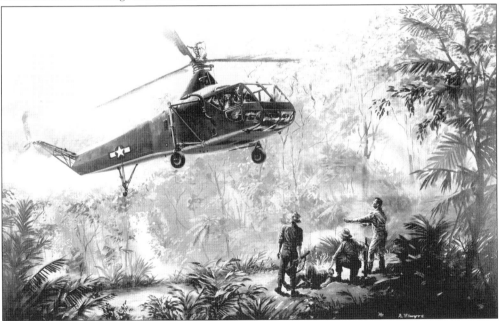

Lt. Carter Harman, USAAF, flew his R-4 from his base in India to a secret Allied airstrip in Japanese-held Burma. From there, he flew four times deeper into the jungle on April 26 and 27, 1944, rescuing three wounded British commandos and their American pilot who were stranded after their medevac aircraft had gone down in the jungle. The photograph was taken of a painting by aviation artist Andy Whyte.

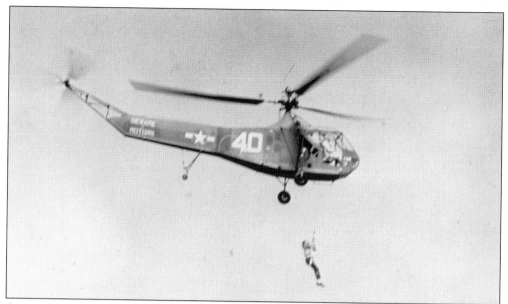

An important piece of equipment for the helicopter was developed by U.S. Coast Guard aviator Frank Erickson. It was the helicopter rescue hoist, first demonstrated in mid-1944 at the U.S. Coast Guard Air Station at Floyd Bennett Field, New York. Today untold thousands of people around the world owe their lives to Erickson's vision. Seen above are pilot Comdr. Frank Erickson, USCG, and rescuee, aviation mechanic Sergei Sikorsky, USCG.

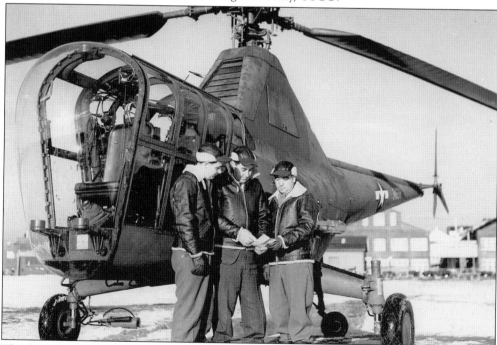

The larger R-5 helicopter first flew on August 18, 1943. Powered by a P&W 450-horsepower engine, it could lift a 1,500-pound payload. Flight testing continued through the winter of 1943–1944, with, from left to right, Bob Decker, Connie Moeller, and chief test pilot D. D. "Jimmy" Viner. Note that on the earlier version, the pilot sat behind the observer-navigator.

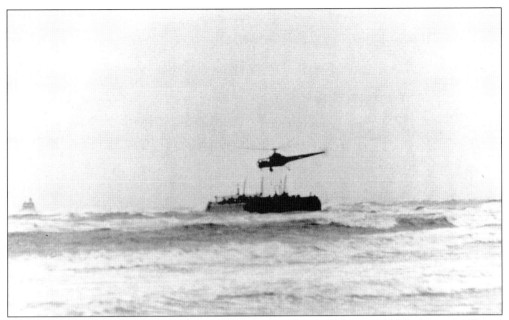

On November 29, 1945, Sikorsky chief test pilot D. D. "Jimmy" Viner and U.S. Army Air Forces captain J. E. Beighle rescued two men from an oil barge sinking in a severe winter storm in Long Island Sound and aground on Penfield Reef, near Fairfield, Connecticut. According to available data, this is the first civil rescue mission, even though the aircraft used was an early-model U.S. Army Air Forces YR-5. It is also the first rescue by hoist on record.

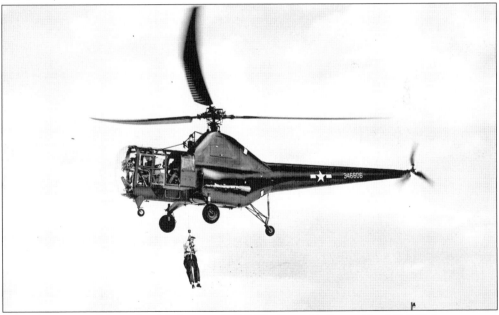

After the rescue of November 29, the same R-5 (U.S. Army Air Forces No. 346606) demonstrates the rescue hoist in Washington, D.C., on December 14, 1945. Interestingly, Viner and Beighle have changed places, with Captain Beighle piloting and Viner manning the rescue hoist. Note that pilot's seat is now in front. A total of 65 R-5s were delivered before the war ended and production was cancelled.

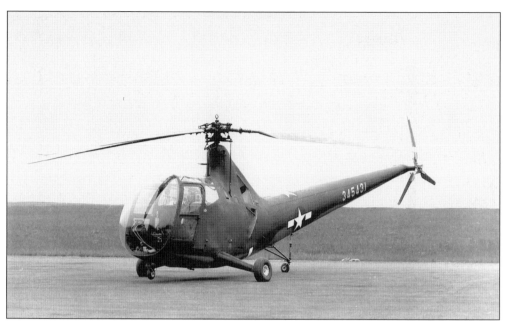

The first R-6 flew in October 1943. It was an improved and streamlined R-4. It used much transmission technology from the R-4 but enjoyed a 240-horsepower Franklin engine instead of the R-4's 180-horsepower Warner engine. Sikorsky built six prototype XR-6s, after which licensee Nash-Kelvinator built another 219 before the war ended.

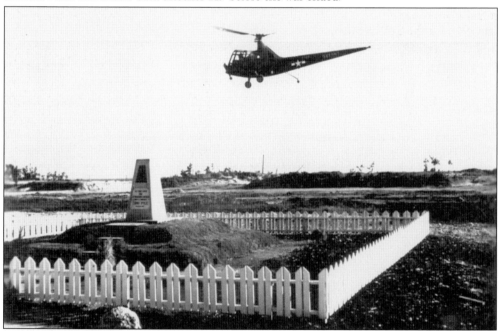

In the final days of World War II, the R-6 saw service in the China-Burma-India theater as well as in the Philippines and Okinawa. They evacuated wounded soldiers to field hospitals and saved several crews who had crashed in the Himalaya Mountains while flying the "hump." Seen above, Col. John Sanduski, USAAF, hovers his R-6 over the Ie Shima, Okinawa, monument to war correspondent Ernie Pyle.

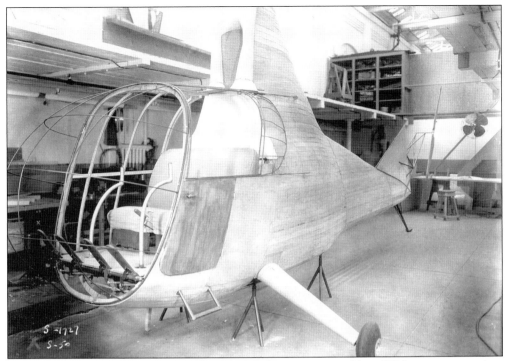

The S-50 was a design study for a small two-seat helicopter, powered by a 150-horsepower engine. It had an estimated gross weight of 1,600 pounds. A full-scale wooden mock-up was completed in late 1943, but the S-50 was never built.

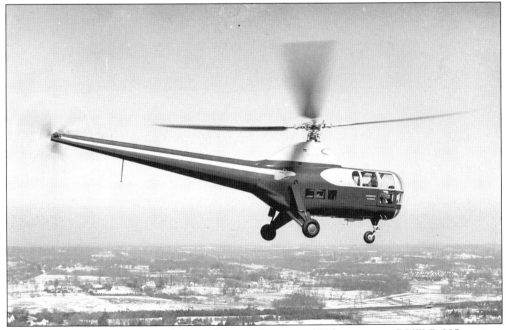

The S-51 was a civil version of the R-5, using the same 450-horsepower P&W R-985 engine. The prototype first flew on February 16, 1946, and was photographed (above) still registered as NX-92800, to show its experimental status. The gross weight was about 4,900 pounds.

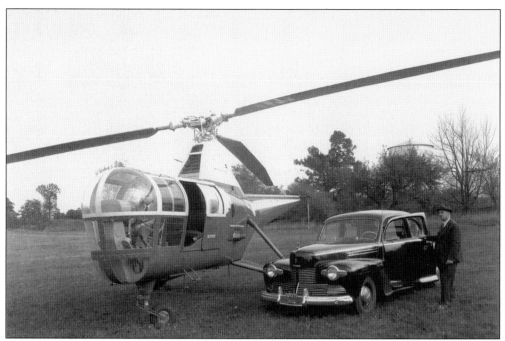

The S-51 was granted civil certification on March 26, 1946, about six weeks after the first flight. This was due to the previous experience gained with the R-5. The second S-51, with civil registration NC-92801, is shown here in Igor Sikorsky's backyard in Long Hill, Connecticut. Chief test pilot D. D. "Jimmy" Viner is at the controls. The photograph is dated October 11, 1946.

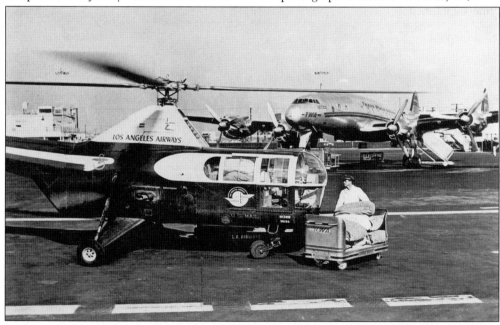

In August 1946, Helicopter Air Transport (HAT), Camden, New Jersey, used its three S-51s to carry passengers between airports and downtown Philadelphia. It was the world's first helicopter airline. In October, Los Angeles Airways opened the first regular airmail service, again with the S-51.

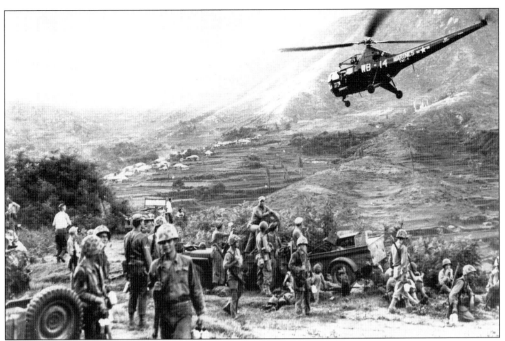

The Korean War erupted in June 1950. The U.S. armed forces had a handful of S-51s in country. At first used for reconnaissance, the S-51s found a critical new mission, flying wounded soldiers out of the rigged mountainous terrain to the mobile army surgical hospital (MASH) units several miles to the rear. In a few weeks, the medical evacuation (medevac) helicopter's role was firmly established.

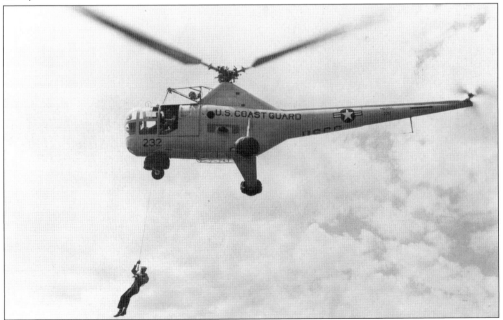

The S-51 served with all the branches of the U.S. military, as well as a dozen foreign forces. Between military and civil versions, Sikorsky built 214 units. In Great Britain, licensee Westland Aircraft built another 137 units for various customers.

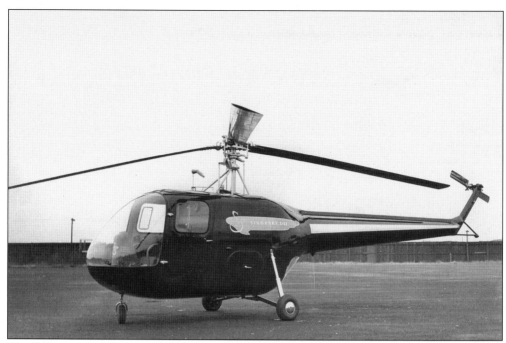

The S-52 was a small two-place helicopter powered by a 165-horsepower Franklin engine. It first flew in February 1947. It was also the first helicopter with all-metal rotor blades. In early 1949, it was modified by the installation of a 245-horsepower Franklin engine. During the summer of 1949, it set two world records, for speed (129 miles per hour) and altitude (21,000 feet).

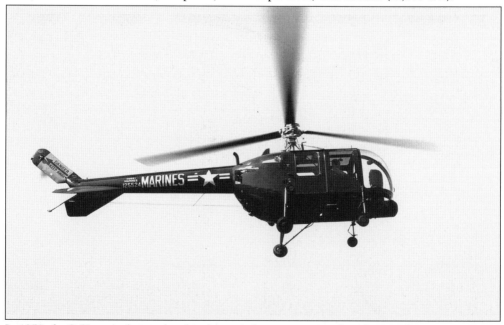

In 1950, the S-52 was redesigned with a deeper cabin to accommodate three to four persons. It was Civil Aeronautics Administration certified for civil use in early 1951, with tail fins for additional stability. The U.S. Marines used them in Korea for medevac and utility missions, as well as observation. Eighty-nine were procured for use by the U.S. Marines and the U. S. Coast Guard.

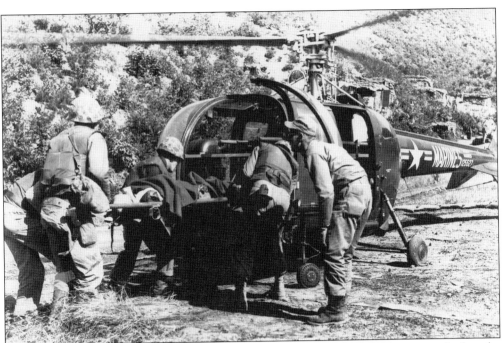

By the end of the Korean War in mid-1953, the Bell and Sikorsky helicopters attached to the MASH hospitals had airlifted over 10,000 wounded soldiers from the battlefield to the hospital. Many would not have survived the trip by jeep or ambulance. In addition, over 1,200 allied airmen and troops were rescued from behind enemy lines. Above, a wounded marine is loaded aboard a HO5S (S-52).

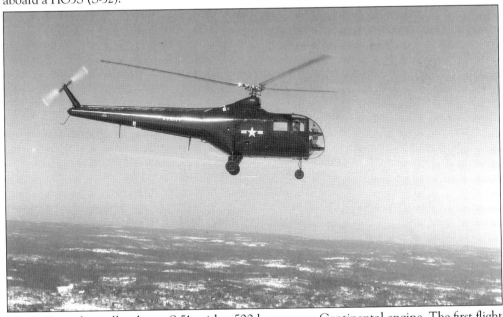

The S-53 was basically a larger S-51, with a 500-horsepower Continental engine. The first flight was in September 1946. Three were built for a U.S. Navy competition for a light utility and rescue helicopter. Due to a limited center of gravity, the S-53 was not ordered into production. It was the second Sikorsky helicopter with metal blades.

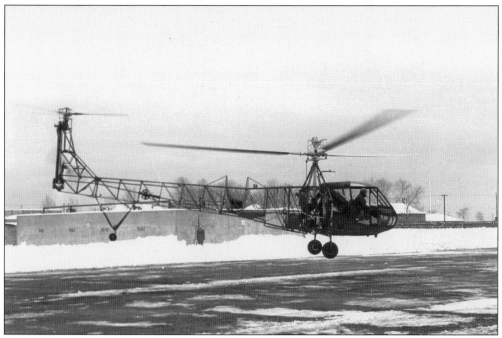

The S-54 was a highly modified R-4, used to evaluate the concept of a sesqui-tandem helicopter. The concept would have allowed a larger center of gravity travel, thus eliminating loading problems. Behind the main rotor was an observer's seat. The first flight was in December 1948. After four and a half hours of flight test, the project was cancelled.

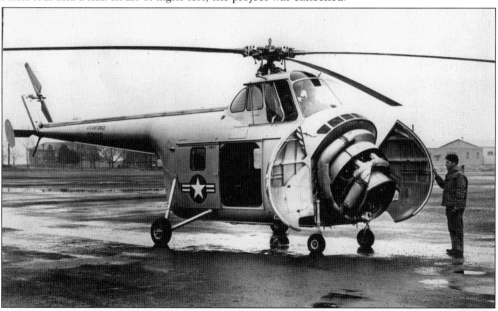

In an amazing demonstration of hard work and engineering management, Igor Sikorsky responded to an Air Rescue Service requirement by designing and building the S-55 in just six months. The prototype first flew in November 1949, just after the U.S. Air Force ordered five "off the drawing board." Pictured here is the first S-55, U.S. Air Force No. 492012. It was an instant success.

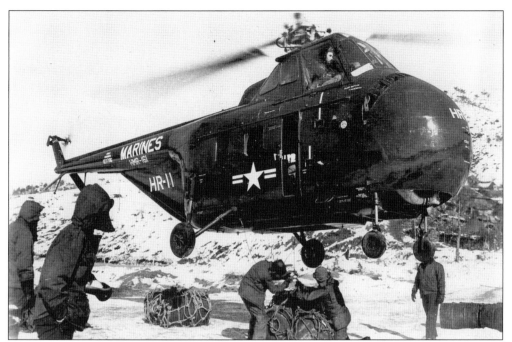

Some of the S-55's advantages were an easily accessible engine of 600 horsepower, a main cabin directly below the rotor to eliminate center of gravity loading problems, and the introduction of a new offset rotor head with a hydraulic servo system (power steering) to reduce pilot workload. Above, somewhere in Korea in 1951, a Marine Corps HRS-1 (S-55) takes on an external sling load.

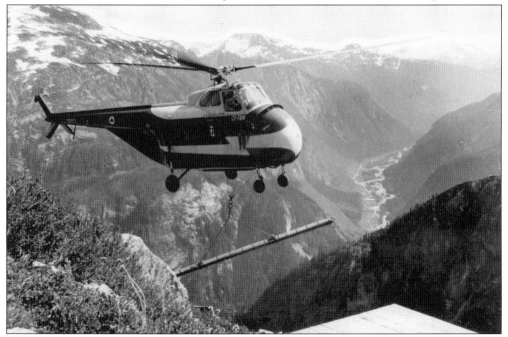

The S-55 rapidly established itself as an industrial workhorse. Here an Okanagan helicopter S-55 flies in lead piping for a construction project somewhere in the high mountains of British Columbia. The date is unknown, but it is probably the mid-1950s.

Several American and European airlines experimented with scheduled airline service with the S-55, but the number of passengers it could carry was too small to make a profit. Later larger helicopters would become more attractive. In all, 1,281 military and commercial S-55s were built by Sikorsky and 477 by licensees in England, France, and Japan.

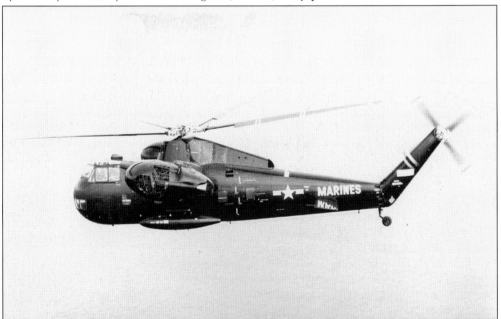

In 1950, the U.S. Marine Corps drew up requirements for a large assault transport helicopter. Sikorsky Aircraft won the design competition. The resulting S-56 was ordered by the U.S. Marines as the HR2S-1 and by the U.S. Army as the H-37. Powered by two 2,100-horsepower piston engines, it first flew in December 1953. A production version is shown above.

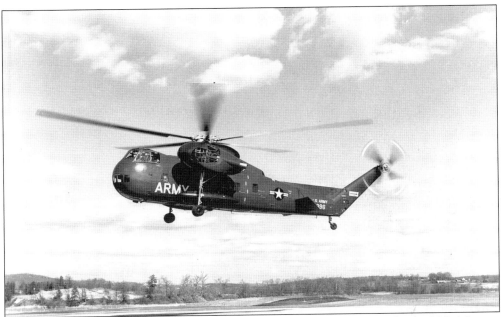

The S-56 could carry 26 assault troops or two jeeps. The S-56 was flown by the U.S. Marines and the U.S. Army in Vietnam, where their heavy-lift capabilities were used to carry damaged helicopters out of hostile territory to be repaired and put back into service.

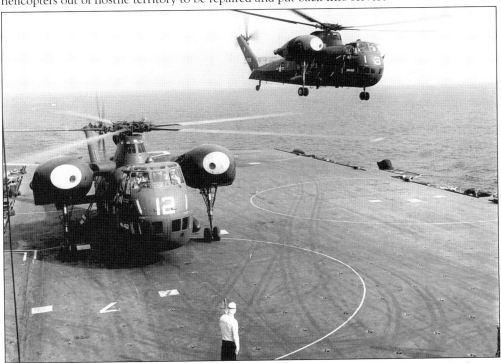

The Marine Corps HR2S-1 was noted as having the first fully automatic folding main and tail rotor. This allowed the big helicopter to become small enough to fit on an aircraft carrier's elevator and be stored below deck. Based at sea, this gave the U.S. Marine Corps literally worldwide capability. Sikorsky Aircraft built a total of 156 of the S-56s for the U.S. Marines and Army.

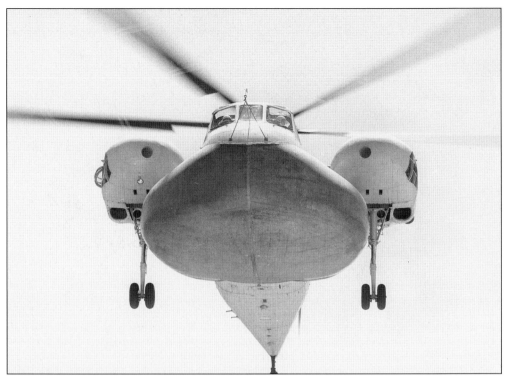

Two S-56 helicopters were rebuilt as HR2S-1W airborne early warning (AEW) aircraft. A powerful radar (the AN/APS-20E) was covered by a large "chin" dome. Preliminary tests suggested that the helicopters were slower and shorter ranged than carrier-based AEW aircraft, and the project was terminated after one was lost in a crash.

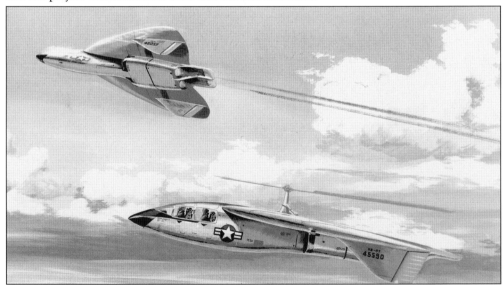

The S-57 was a high-speed delta winged project studied from 1951 through 1953. It was a jet-powered fighter with a single-bladed, tip jet–driven rotor that could be stopped and started in flight to provide for vertical takeoff and landing. In forward flight, the rotor blade would retract into a recess along the top of the fuselage. There was no activity after 1953.

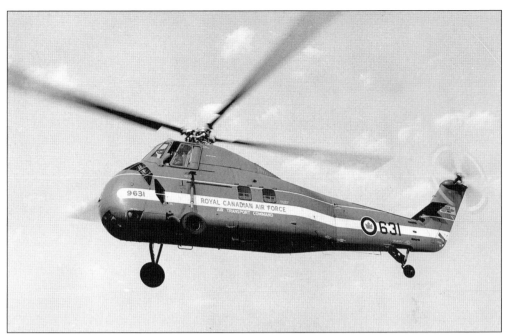

The S-58 first flew in March 1954, powered by a 1,525-horsepower Wright engine. Fully loaded it weighed 13,000 pounds. It was so successful that it was built by Sikorsky Aircraft, Westland in England, and Sud-Aviation in France. When the S-58's 25-year production run was over, more than 2,300 had been built.

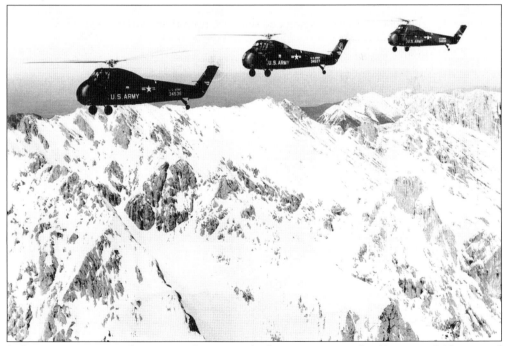

U.S. Army H-34s are flying over Germany's highest mountain, the Zugspitze. Military and civilian versions of the S-58 were used by the armed forces and commercial operators of more than 60 nations around the world.

In 1959, Soviet premier Nikita Khrushchev visited Washington, D.C. His host, Pres. Dwight Eisenhower, invited Khrushchev to visit Camp David. In this historic photograph, Eisenhower persuades a skeptical Khrushchev to board the helicopter. The aircraft U.S. Navy BUNO 147161 is the first Marine One.

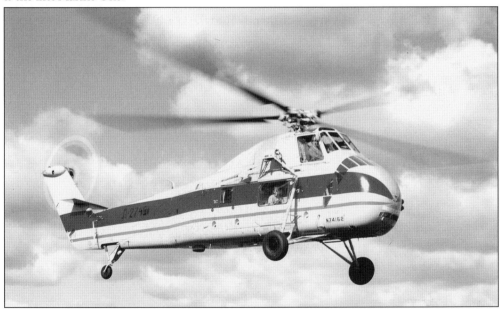

Evidently, Premier Khrushchev enjoyed his flight in the VIP Marine One. Upon returning to Washington, D.C., he asked President Eisenhower permission to buy three identical examples. Eventually the order was cut back to two ships. Seen above, one of the helicopters is tested prior to being shipped to the Soviet Union in late 1960. One of the helicopters is on display at the Russian Air Force Museum at Monino, near Moscow.

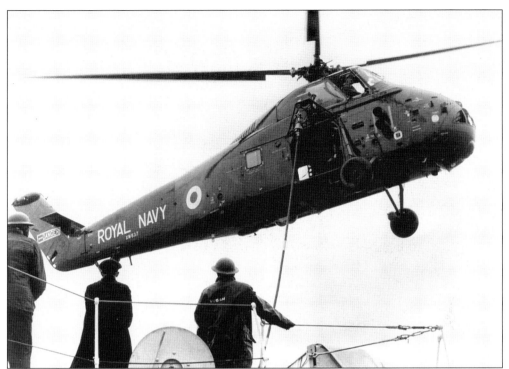

In Great Britain, Westland Aircraft rapidly redesigned the S-58 into a family of jet turbine helicopters. Over 400 were built with a variety of engines. Above, a Westland Wessex, powered by a 1,450-horsepower Napier Gazelle turbine, tests refueling equipment developed by Flight Refueling Ltd. The Wessex was in service from 1961 to the late 1990s with the Royal Air Force and Royal Navy. (Courtesy of Flight Refueling Ltd.)

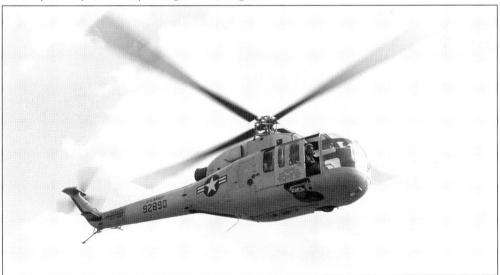

The S-59 was a highly modified S-52. It first flew in June 1954. It had a four-bladed main rotor, a three-bladed tail rotor, and retractable landing gear. It was powered by a Turbomeca Artouste turbine of 425 shaft horsepower. Although it established a speed record of 156 miles per hour in August 1954, only one was built.

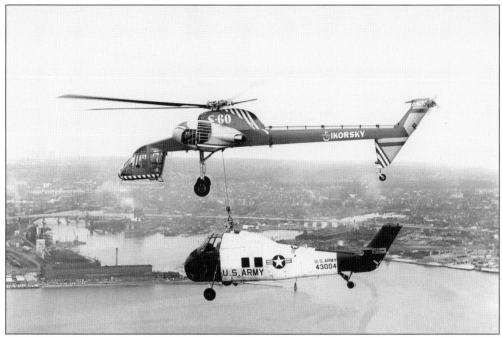

The S-60 first flew in March 1959. It was built to test the concept of a flying crane with a rear-facing pilot to provide excellent visibility, and thus control, while lifting or depositing cargo. The S-60 rapidly proved the concept and led the way to larger cranes. Here the rear pilot monitors load stability.

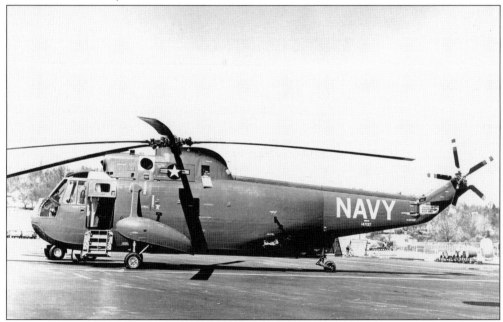

When the prototype XHSS-2 (U.S. Navy BUNO 147137, pictured above) first flew in March 1959, few could have predicted its worldwide success. Powered by two GE T-58 turbines of 1,100 horsepower each, the Sikorsky S-61 had a gross weight of 19,000 pounds and cruised at 130 miles per hour. In its antisubmarine role, it carried a crew of four.

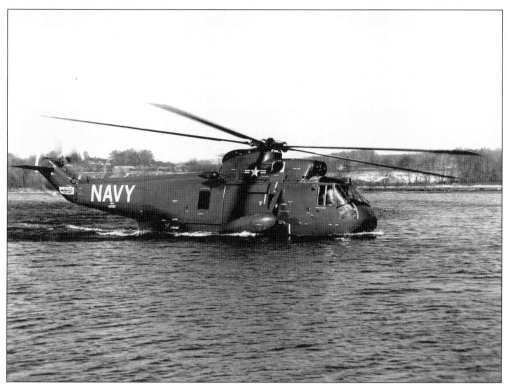

Here the prototype XHSS-2 (S-61) demonstrates its capabilities on the water, during an April 1959 show for senior aviation reporters. When the antisubmarine electronics were removed, the roomy cabin could fit 20 to 24 combat-equipped soldiers or 6,000 pounds of cargo.

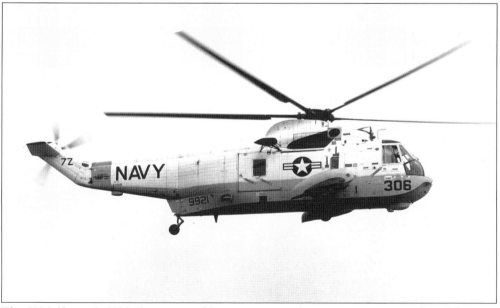

The SH-3 (formerly HSS-2) series steadily grew in versatility as new missions and modifications were introduced. T-58 engine power also increased to keep pace with the weight growth. However, most of the SH-3 series remained dedicated antisubmarine helicopters.

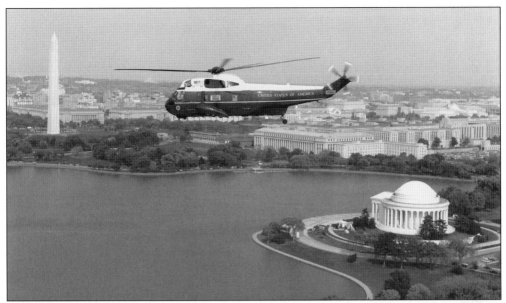

The Sikorsky VH-3D (S-61) is used by the president of the United States. The presidential helicopter flight is manned by specially selected U.S. Marine Corps pilots and maintenance specialists. Other Sikorsky Aircraft helicopters carry many heads of state in Europe, Asia, and the Far East. Twenty-three specially equipped VH-3D helicopters were built.

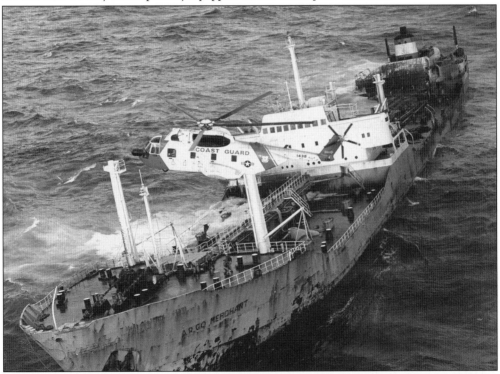

The HH-3F (S-61R) was designed with a rear-loading ramp, and sponsons replaced the floats of the SH series. This aircraft model served with the U.S. Coast Guard and the U.S. Air Force. Above, a U.S. Coast Guard HH-3F hovers over a sinking tanker as the crew is hoisted to safety.

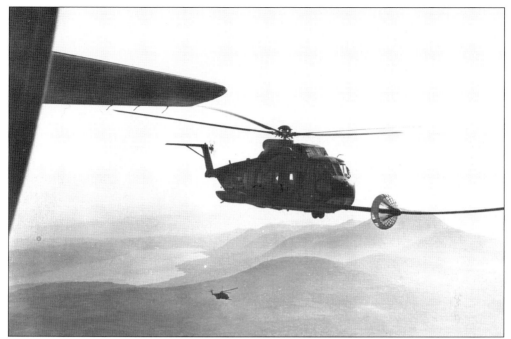

The U.S. Air Force HH-3E model (S-61R) had the capability of being refueled in flight. On May 31, 1967, two HH-3Es took off from New York. Thirty-one hours later, on June 1, they landed in Paris, having flown 4,271 miles. Seen above is one of the two U.S. Air Force helicopters refueling from a C-130 over Scotland.

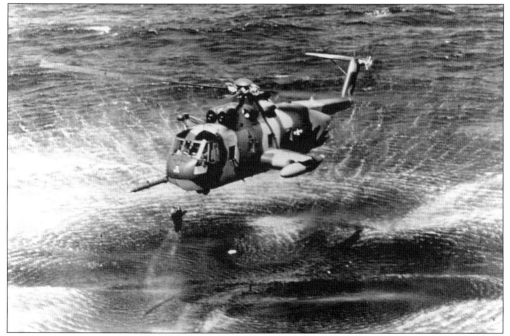

A U.S. Air Force HH-3E of the Air Rescue and Recovery Service, (here, the 37th Air Rescue and Recovery Service) picks up a downed pilot from hostile waters in the Tonkin Gulf. This HH-3E is also equipped with the air-to-air refueling probe. A total of 199 S-61Rs were built.

The S-61L (land) and S-61N (nautical) had a 50-inch-longer cabin for 28 passengers. The L model first flew in December 1960, the amphibious N model in August 1962. A total of 136 were built; most are still flying in offshore transportation and logging. A total of 1,431 military and commercial S-61 derivatives were built around the world.

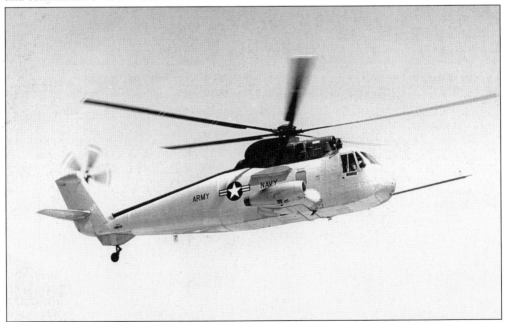

Jointly funded by the U.S. Army and Navy, the experimental S-61F first flew in May 1965. In addition to the two 1,250-horsepower jet turbines driving the main rotor, it had two P&W J-60 jet engines of 2,750 pounds thrust each. Although it reached a speed of 242 miles per hour in level flight in July 1965, the program was terminated late that year.

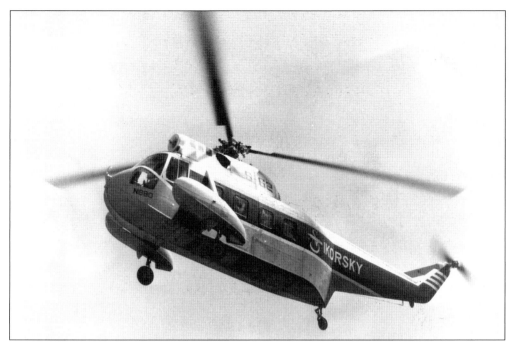

The S-62 first flew in May 1959. It used many parts (transmission, rotor system, and so on) from the S-55. Powered by one GE T-58 turbine, it used only a maximum of 750 horsepower due to gearbox limitations. Weighing up to 8,000 pounds, it could carry 10 troops plus a crew of two. Civil and military deliveries started in 1960. This photograph shows the prototype N-880.

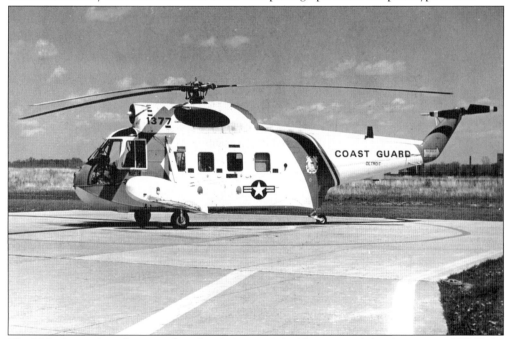

The U.S. Coast Guard procured its first S-62s in 1962. They carried the designation HH-52 for most of their service life. Eventually the U.S. Coast Guard would order 99 units for use around the world. The last of the HH-52s would be retired in 1989.

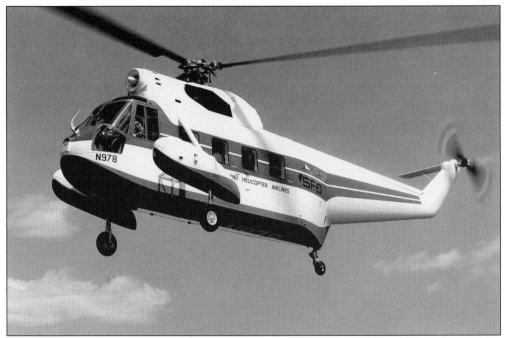

The S-62 was also used by a number of specialized helicopter airlines. Mitsubishi built 25 for the Japanese Coast Guard and several Far Eastern air forces. In all, 170 were built. Above, one of the S-62s operated by San Francisco/Oakland Airways is seen.

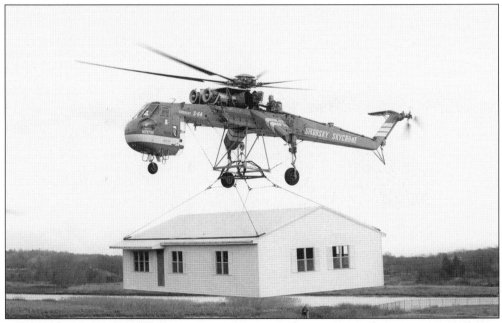

As a result of the S-60 demonstrator, and growing interest in the crane concept, a joint German-American project resulted in the S-64A. Its first flight was in May 1962. Two went to (then) West Germany for further testing. Powered by two P&W JFTD-12 turbines of 4,500 horsepower (later 4,800 horsepower), the S-64 could lift 25,000 pounds. After additional testing, the U.S. Army ordered another 95.

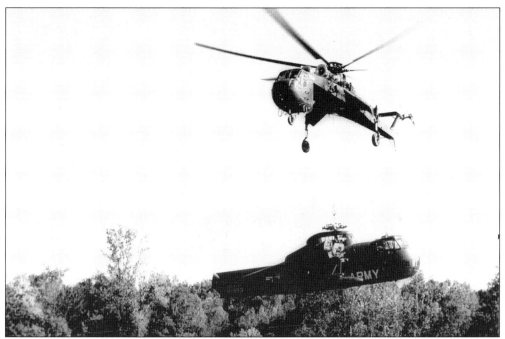

As the S-64s (U.S. Army CH-54) arrived in Vietnam, they were put to work salvaging crash-landed aircraft and helicopters. Four cranes assigned to one combat zone in Vietnam salvaged over 45 downed aircraft (mostly helicopters) in just three months. Most of the salvaged aircraft were repaired. The U.S. Army estimated the value of the salvaged aircraft at $15 million, twice the cost of the four cranes.

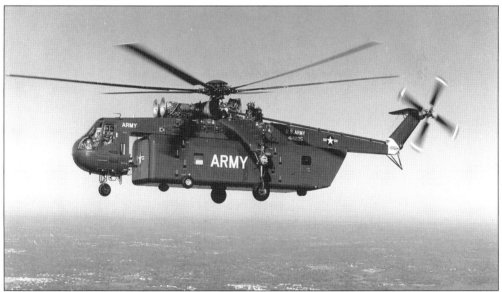

Pods designed for transporting troops, mobile command posts, and field hospitals were used in Vietnam. In a 1965 test at Fort Bragg, 87 combat-equipped troops, plus the three-man crane crew, were flown in a pod similar to the one shown above. Hospital pods were developed by 1967. Today a growing fleet of rebuilt cranes are used as firefighting, logging, and myriad heavy-lift applications.

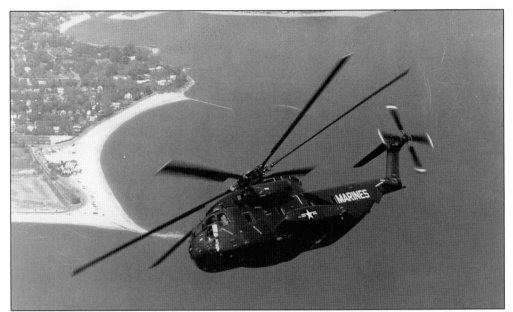

The S-65 or CH-53A was built for the U.S. Marines as a heavy assault helicopter. The first flight was in October 1964. Powered by two GE T-64 turbines of 4,000 horsepower each, it carried 37 combat troops or up to 24 stretchers plus four attendants. The CH-53 deliveries started in 1966, and the first CH-53s arrived in Vietnam in January 1967.

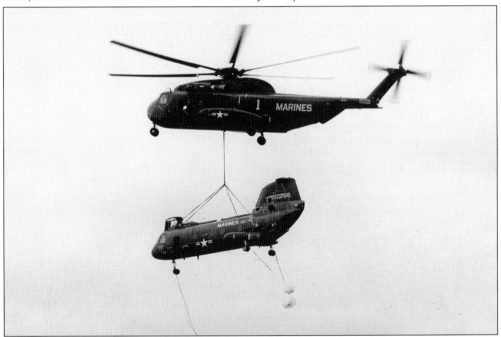

During their first six months in Vietnam, the Marine Corps CH-53s literally "paid their way" by retrieving about 157 downed aircraft worth millions of dollars. Smaller aircraft and helicopters were flown out "as is." Larger aircraft had their engines and rotor blades removed to reduce weight. In the photograph above, one of 17 CH-46 helicopters salvaged during the six-month period is flown to safety.

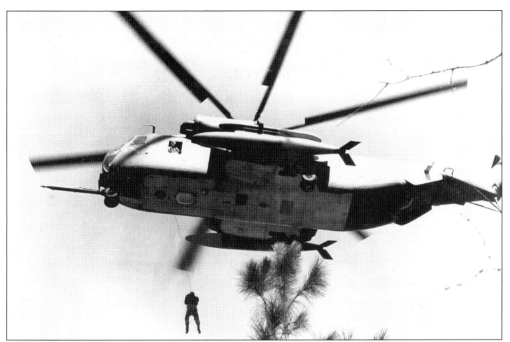

The first U.S. Air Force HH-53B combat rescue helicopters arrived in Vietnam in September 1967. Visible changes were an air-to-air refueling probe and two 650-gallon auxiliary fuel tanks. Invisible changes included extensive defensive armor protector for crew, engines, and vital accessories. Three 7.62-millimeter GE miniguns provided defensive firepower. The H-53 series participated in many daring rescues of downed aircrews.

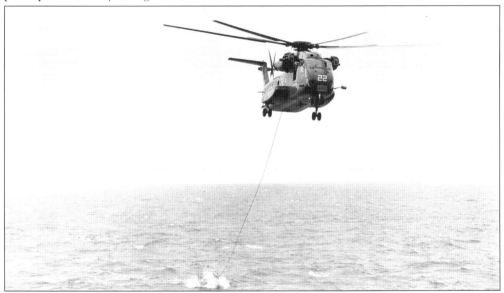

Although some early experiments in minesweeping had been done with SH-3A (S-61) helicopters, the greater power and endurance of the RH-53 was decisive. After the Vietnamese signed the cease-fire agreement in January 1973, the U.S. Navy cleared North Vietnam's harbors from February to late July 1973. The technology of minesweeping by helicopter is growing in importance as many U.S. Navy missions move into shallower water.

Between 1971 and 1975, Germany built 110 CH-53G helicopters for its army. The heavy lifters have been involved in many humanitarian missions, such as the evacuation of 3,786 survivors of disastrous avalanches in Austria in February 1999. In May 2000, German Army Aviation celebrated (above) 500,000 flight hours on the helicopter fleet. Between the United States and Germany, a total of 522 H-53s were built.

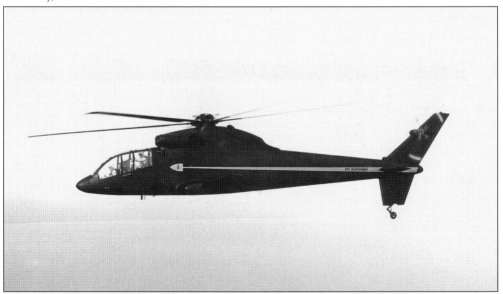

In answer to U.S. Army aviation interest in a heavy attack helicopter, Sikorsky Aircraft built the S-67 as a private venture. The S-67 first flew in August 1970, powered by two GE T-58 turbines of 1,500 horsepower each. Four short months later, it established a speed record of 220 miles per hour. At a gross weight of up to 22,000 pounds, it could carry 15 troops or 8,000 pounds of external cargo.

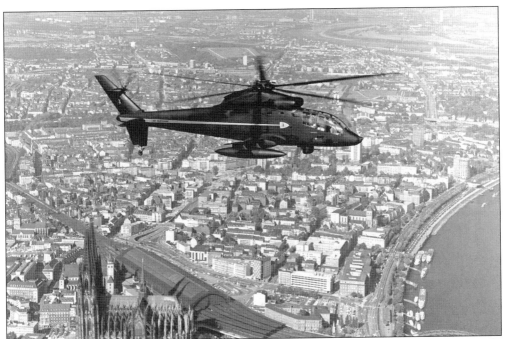

After extensive weapons testing and demonstrations in the United States, the S-67 (informally named the Blackhawk) toured Europe and the Near East. From September to November 1972, the S-67 accumulated 136 flight hours while covering most of the European countries from England to Iran and back. Above, the S-67 flies above the famed spires of the Cologne Cathedral and the Rhine River. Only one was built.

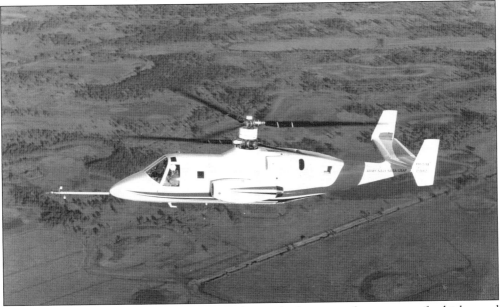

The S-69 first flew in July 1973. Two aircraft were built to test the concept of a high-speed contra-rotating rigid rotor. After one crashed, the remaining S-69 flew as a pure helicopter. In early 1977, two 3,000-pound thrust P&W J-60 turbojets were added. Speed increased from 184 miles per hour to 322 miles per hour. Research terminated in late 1978.

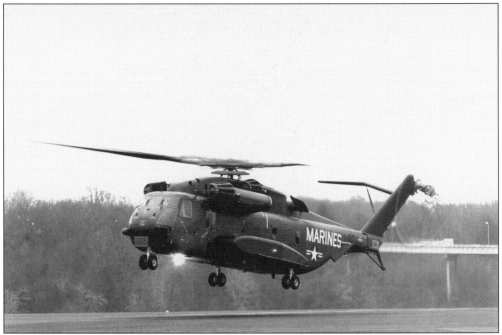

The CH-53E resulted from a joint U.S. Navy–U.S. Marine Corps requirement for a helicopter capable of lifting 16 tons. Based on the CH-53, the E model had three GE T-64 engines of 4,300 shaft horsepower each, a seven-bladed main rotor 79 feet in diameter, and a 20-foot-diameter tail rotor. Its first flight was in March 1974. The CH-53E was built as a transport and the MH-53E as a minesweeper.

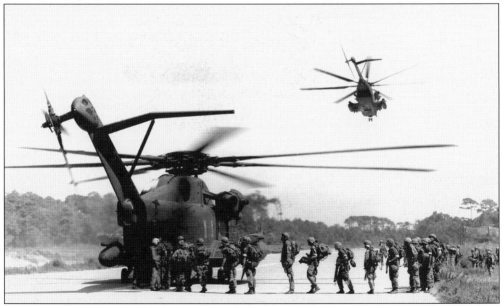

The CH-53E has a cabin about six feet longer than the CH-53D. It can carry 55 combat-equipped troops, or 30,000 pounds of internal cargo. When carried externally on a cargo hook, a load of 32,200 pounds can be lifted. The CH-53E is identified not only by the third engine but by the slanted tail rotor and gull-wing tailplane.

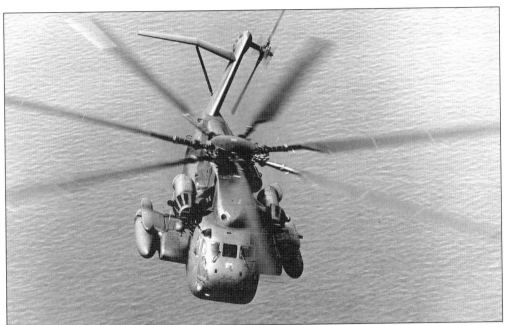

Two Marine Corps CH-53E helicopters were the core of a "trap" team that rescued U.S. Air Force captain Scott O'Grady on June 8, 1995, after he had been shot down by Bosnian forces. The U.S. Marines Tactical Recovery of Aircraft and Personnel (TRAP) teams are the combat search and rescue arm of the corps.

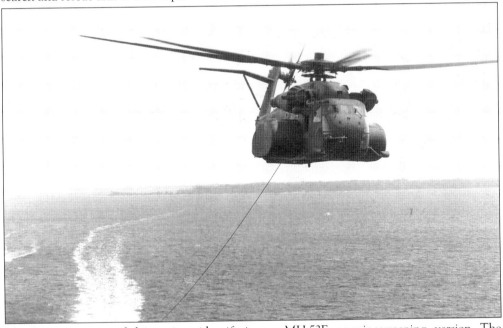

The large sponsons of this variant identify it as a MH-53E, or minesweeping, version. The sponsons hold 3,200 gallons of fuel, while the aerial refueling boom can extend the normal four-hour mission if needed. Constant improvements to the towed "sled" allowed for more precise identification and destruction of anti-shipping mines. A total of 191 CH/MH-53Es were built, including 11 for Japan.

The photograph above was taken in May 1969 during a reception in New York on the occasion of Igor Sikorsky's 80th birthday. Many at the table were already friends in the mid-1920s while flying out of Roosevelt Field. Obviously enjoying one other's company, pictured are, from left to right, aviation legends Casey Jones, Roscoe Turner, Igor Sikorsky, Eddie Rickenbacker, Grover Loening, and Frank Gregory.

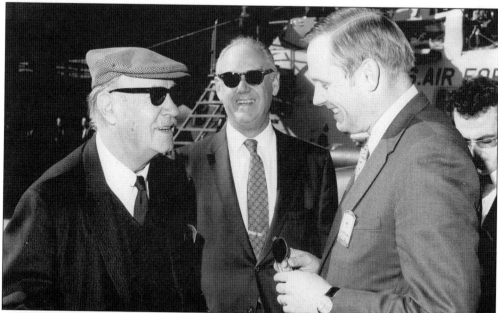

Two aviation legends meet: Neil Armstrong, first man on the moon, chats with Igor Sikorsky (left) while a beaming Frank Delear, Sikorsky's public relations director, looks on. It is October 29, 1970. Later Armstrong dedicated a photograph of the meeting as follows: "To Igor Sikorsky—with admiration and respect of a junior exponent of vertical takeoff and landing." It was one of Sikorsky's favorite photographs.

One of the last photographs of Igor Sikorsky shows the obviously content aviation pioneer while flying in one of the VH-3D presidential helicopters. Twenty-three were built. One was given to Egyptian president Anwar Sadat by Pres. Richard Nixon.

On October 26, 1972, Igor Sikorsky passed away in his sleep. He was 83. As he was interred on October 30 in Connecticut, a group of Sikorsky helicopters flew over the funeral to pay a last tribute. Far above, by incredible chance and timing, two jet contrails formed a huge white cross against the deep blue sky.

In the early 1950s, the volume of helicopter orders began to strain the Bridgeport plant's facilities. The decision was made to build a new factory in Stratford. As construction started, Igor Sikorsky requested that his office be located not in the executive wing but as close to the engineering department as possible. His wish was granted. The new 1.4 million-square-foot plant (currently expanded to 2.1 million square feet) was dedicated in October 1955. After retiring in 1957, Igor Sikorsky continued as an elder statesman and consultant. The office saw many visits by aviation leaders, political figures, and highly decorated rescue pilots and aircrews. After his death in 1972, his office was left largely as it was on his last day at work. Today it is an impressive part of the Sikorsky legacy, containing much of his personal memorabilia and the medals and awards earned during his remarkable 60-plus years of pioneering in aeronautics. Note in the foreground the model of the circular rescue cage Sikorsky envisioned for the crane helicopter.

Four

THE LEGACY CONTINUES

In January 1972, the U.S. Army published the performance requirements for a new-generation utility helicopter. The U.S. Army designation was UTTAS, for Utility Tactical Transport Aircraft System. Based on combat experience gained during the Vietnam War, the requirements were severe, calling for unprecedented performance and survivability while carrying two pilots, a crew chief, and an 11-man squad or an 8,000-pound load on an external cargo hook. Since the requirement was for 1,100 helicopters, a fierce design competition erupted among the major helicopter manufacturers. In August 1972, the U.S. Army announced that Boeing-Vertol and Sikorsky were finalists in a "fly before you buy" competition. The race was on.

The prototype S-70 first flew in October 1974. Both candidates were put through a strenuous test program. In December 1976, Sikorsky was declared the winner. When the first production S-70, now renamed the H-60 Black Hawk, was delivered in October 1978, few could have predicted its success. Nearly 3,000 S-70s have been delivered worldwide and production continues apace for American and international customers.

The Black Hawk continues the proud legacy of Igor Sikorsky's prophecy that the helicopter would prove to be "a unique instrument for the saving of human lives." U.S. Army Black Hawk helicopters saved hundreds during natural disasters and avalanches in the Alps and floods in Europe. U.S. Navy SH-60 Seahawks from the aircraft carrier USS *Abraham Lincoln* were among the first helicopters to bring food, water, and medical supplies—and hope—to the desperate survivors of the December 2005 tsunami disaster in Indonesia. U.S. Coast Guard Jayhawks, U.S. Navy Seahawks, U.S. Air Force Pave Hawks, and National Guard Black Hawks saved tens of thousands after Hurricane Katrina ravaged New Orleans and the gulf coast.

The S-72 Rotor Systems Research Aircraft, or RSRA, was jointly funded by NASA and the U.S. Army. Using the hardware from an S-61, the aircraft was basically a flying test bed that could be flown as a pure helicopter. By removing the main rotor and bolting on the detachable wing, it became a conventional airplane. With the rotor, and the wing attached, it was made into a compound helicopter by adding two GE TF34-400 9,000-pound thrust turbofans. The first flight as a helicopter was in October 1976, and the first flight as a compound helicopter was in April 1978. Two RSRA test beds were built and tested at the Sikorsky Aircraft factory and at the U.S. Army test center at Edwards Air Force Base. After the research programs were flown, the project was discontinued.

The S-75 was also called the ACAP due to the project's name: Advanced Composite Airframe Program. Funded by the U.S. Army, it was designed to study the use of composite materials in building helicopter airframes and structures. The ACAP flew in late 1984. Considerable experience was gained, which proved valuable in later programs such as the RAH-66 Comanche, the CH-53E, and others.

The S-76 prototype first flew in March 1977. Designed to meet the growing market for a 12-passenger offshore crew-change vehicle, it was easily adapted into an executive transport, commuter airliner and as a highly sophisticated search and rescue helicopter. The high speed of the S-76, and a cabin large enough to house complex trauma equipment plus two or more medical personnel in addition to the patient, has resulted in a growing number of these aircraft being used in the EMS (emergency medical service) missions. Some 700 S-76 helicopters now fly in some 60 countries around the world. The S-76 has evolved from the A model into the latest D model, with deliveries starting in 2008.

In the late 1970s, U.S. Army aviation leaders began to study the requirements for a small, nimble scout helicopter with an antitank capability. The helicopter had to survive in a sophisticated, high-intensity battlefield; hence, it had to have low noise levels, minimal radar "signature," and low-temperature jet engine exhaust plumes to reduce the threat from heat-seeking missiles. The program was first known as the LHX and then as the RAH-66 Comanche. A joint Boeing-Sikorsky team designed and flew two prototypes. However, the fall of the Communist empire eliminated the high-intensity threat, and the Comanche program was eventually cancelled in 2004.

The S-92 first flew in December 1998, after nearly seven years of design work. The S-92 is a risk-sharing project, with Sikorsky Aircraft responsible for main and tail rotors, transmissions, final assembly, and flight test. The rest of the S-92 structures and systems were designed and are being manufactured by five partners: AIDC of Taiwan, Embraer in Brazil, Gamesa in Spain, Jingdezhen in China, and Mitsubishi in Japan.

The key to the successful program was a satellite-based international computer network that created a three-dimensional full-scale electronic mock-up of the S-92. The six-partner design and manufacturing team each used the computer model to detail-design its portion of the S-92. When all the major sections from around the world arrived at the Sikorsky plant for final assembly, it is said that only one shim was needed on the first S-92. No shims were needed on the second and following aircraft. The S-92 won the prestigious Collier Trophy in 2002 and is now in production for military and civil operators.

After decades of excellent cooperation with family-owned Schweizer Aircraft, a leader in small helicopters, "quiet" reconnaissance aircraft, and unmanned aerial vehicles, Sikorsky Aircraft established a joint venture with a Chinese firm to build and market Schweizer helicopters in the Far East. Then, in September 2004, Schweizer became a subsidiary of Sikorsky Aircraft. In June 2005, Sikorsky revealed plans for an experimental coaxial rotorcraft, the X-2, to be built at the Schweizer Aircraft facility. The X-2 will explore future coaxial applications.

In December 2005, Sikorsky Aircraft bought Keystone Helicopters, a highly respected helicopter service and support center founded in 1953 by Peter Wright, one of the original Flying Tigers of World War II fame. A number of other mergers, with specialist teams such as Derco and HSI, have strengthened Sikorsky Aircraft in the service and support area of operations.

In April 2006, the U.S. Marine Corps awarded Sikorsky Aircraft a contract to develop a new heavy-lift helicopter similar to the CH-53E, to be designated the CH-53K. Three 6,000-horsepower turbine engines will power the new helicopter, enabling it to carry a 27,000-pound load 110 miles from takeoff, hover for five minutes to position the load, and then return 110 miles to its point of departure. The new helicopter could enter service by 2015–2016.

Although new technology may eventually change the helicopter's shape, one thing is certain: thanks to the skill and dedication of the aircrews, helicopters will continue to save lives.

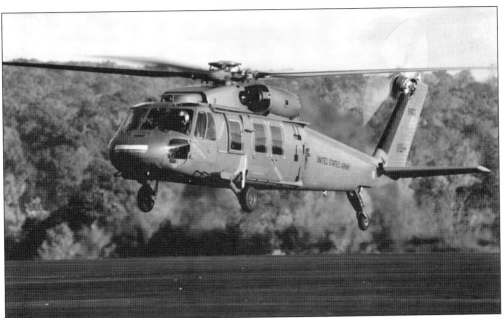

The prototype S-70 Black Hawk first flew on October 17, 1974. The extremely compact design was dictated by U.S. Army requirements that the helicopter could be "folded up" to fit in a C-130 for air transport. Note the low-set main rotor and the horizontal fixed tail surface. Both items would be modified as a result of the flight test program. It was designated H-60 by the U.S. military.

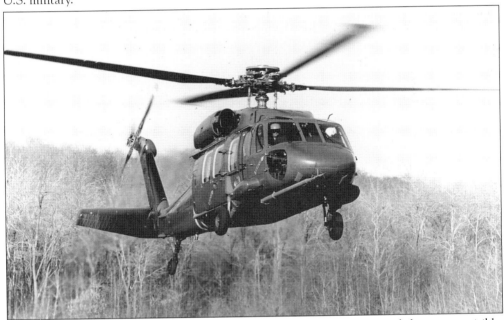

By mid-1975, as U.S. Army pilots test the three YUH-60A prototypes, several changes are visible. The main rotor has been raised to avoid airflow turbulence over the fuselage top. The "stabilator" automatically changes its angle as a function of airspeed. The canted tail rotor provides control and adds nearly 400 pounds of lift. The nose boom contains test instrumentation and will be removed.

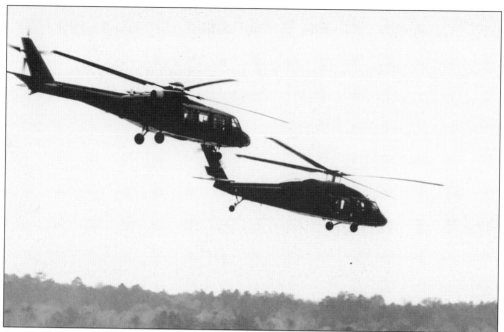

A rare photograph shows the two competing aircraft, the Boeing-Vertol YUH-61A (left) and the Sikorsky YUH-60A during the U.S. Army tests. This photograph was taken in mid-1976, either at Fort Rucker or Fort Campbell.

In June 1979, a group of government and military leaders were invited to witness the delivery of the first production UH-60A to the U.S. Army. Next to the Black Hawk (right) is Sikorsky Aircraft's first production helicopter, the R-4. The evolution of the helicopter in about 37 years was evident as one compared the 1942 two-seat, 200-horsepower R-4 with the 14-seat, 3,000–shaft horsepower UH-60A.

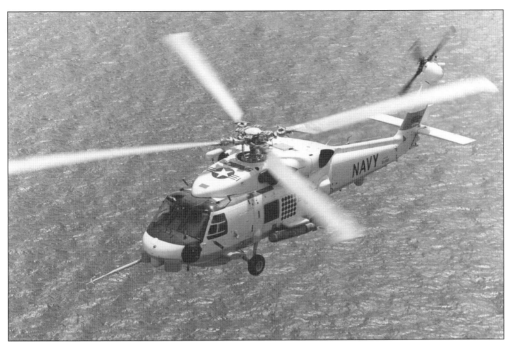

The U.S. Navy's antisubmarine SH-60 Seahawk flew in December 1979. Although roughly 60 percent interchangeable with the Black Hawk, major differences included folding main and tail rotors, a relocated tail wheel, and a profusion of antennas. Inside the helicopter was equipped with a sophisticated avionics and sonar system for locating hostile submarines.

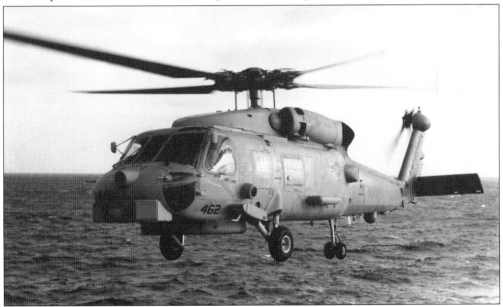

The SH-60B has gained wide acceptance around the world and is operating by a growing number of navies. As with the Black Hawk, the growth of engine power in the GE T700 turboshaft from 1,560 shaft horsepower to 1,900 shaft horsepower is reflected in a growth from 16,500 pounds takeoff weight to as much as 21,800 pounds. The relocated tail wheel is clearly visible in this photograph.

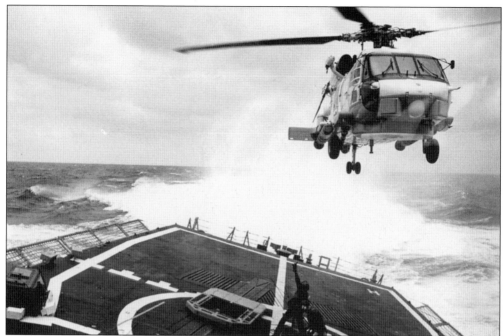

The Recovery Assist Secure and Traverse (RAST) system allows operation from smaller ships. A crewman snaps a special cable to the RAST probe behind the helicopter's main wheels. The hovering helicopter is then "reeled in" and lands atop the RAST "sled," whose hydraulic jaws snap shut around the probe. The RAST system then rolls the helicopter into the ship's hangar. The system allows flight operations up to 15 degrees of ship's roll.

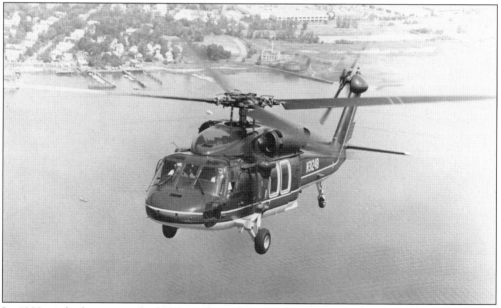

In 1983, with the approval of U.S. authorities, a commercial version of the Black Hawk was shown in Lhasa, Tibet. During the flight demonstrations, landing and takeoffs were performed at altitudes exceeding 17,000 feet, while flying at altitudes of over 24,000 feet. The Peoples Republic of China took delivery of 24 S-70Cs in 1984–1985 for utility and rescue operations.

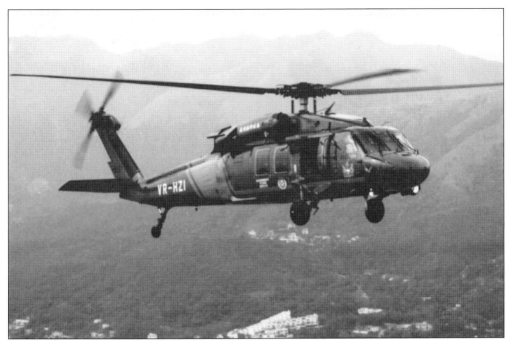

Above is a commercial S-70 Black Hawk flown by the then Hong Kong Government Flying Service, equipped with rescue hoist and powerful searchlight, performing a wide range of missions, including search and rescue. At least 25 governments worldwide have selected S-70 Hawk family helicopters to upgrade their aviation fleets.

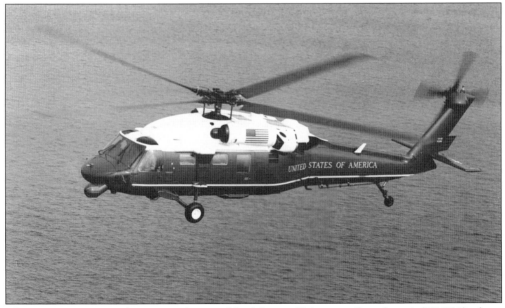

The VH-60N appeared in 1988. Operated by Marine Helicopter Squadron 1 (HMX-1), these aircraft carry the president and VIP guests. Very sophisticated avionics gear, controlled by a radio operator's station in the cabin, allows the president to communicate with literally any point on earth or at sea. As with most members of the Black Hawk family, these helicopters are air transportable by C-130, C-141, and C-5 aircraft.

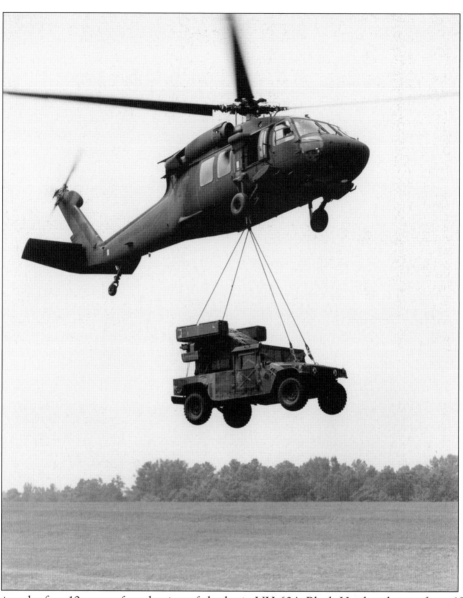

During the first 10 years of production of the basic UH-60A Black Hawk—that is, from 1979 to 1989—additional equipment and structural refinements slowly but steadily added roughly 900 pounds to the empty weight of the U.S. Army aircraft. In time, this began to affect aircraft performance. Meanwhile, the U.S. Navy had started procuring the Seahawk, with uprated GE 1,890–shaft horsepower engines and an improved 3,400-horsepower main gearbox. Other Seahawk improvements, including strengthened control elements, were also in production for the U.S. Navy. The U.S. Army incorporated these improvements in the new UH-60L, which entered production in October 1989. The U.S. Army's version of the GE T700 engine was uprated to produce 1,940 shaft horsepower. With 24 percent more power, the L model's mission gross weight grew to 23,500 pounds, and external cargo capacity grew to 9,000 pounds. This allowed the UH-60L Black Hawk to carry the U.S. Army's HMMWV (High Mobility Multipurpose Wheeled Vehicle), including the Avenger antiaircraft missile system version weighing 8,750 pounds.

Just over 41 years of Sikorsky engineering separate the VS-300 (1943 version) from the U.S. Coast Guard HH-60J, or Jayhawk as it is known in that service. The VS-300, as seen here, had a 100-horsepower engine. The Jayhawk has a total of some 3,200 shaft horsepower.

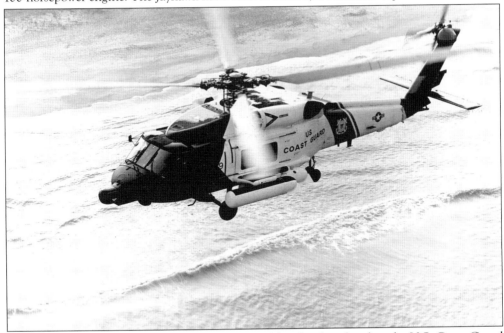

The HH-60J first flew in 1986 and is a Black Hawk/Seahawk tailored to the U.S. Coast Guard Medium Range Recovery (MRR) mission. This means a 300–nautical mile mission radius carrying a crew of four, recovery of up to six persons at midpoint, and a return of up to 300 nautical miles. In addition to the search and rescue mission, it is often used for drug interdiction.

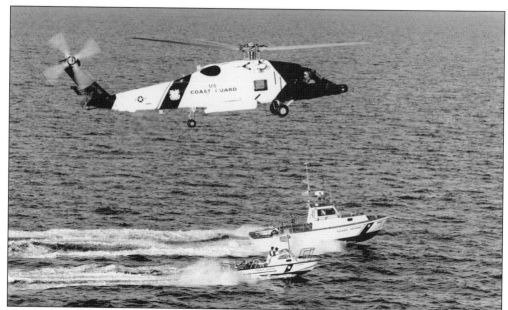

The U.S. Coast Guard has developed a number of techniques to stop drug smugglers using "go-fast" powerboats. They include launching an armed helicopter and speedboat from the same cutter. The helicopter stops the "go-fast" boat, and the Coast Guard moves into to arrest the smugglers and confiscate the evidence.

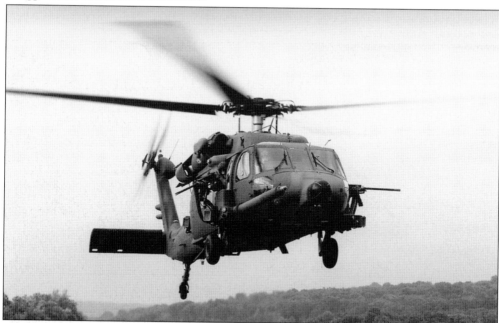

The impressive performance of the UH-60L was used by the U.S. Air Force to build the HH/MH-60G Pave Hawk, which entered service in 1982. Designated for difficult long-range combat search and rescue, it is also used to carry the U.S. Air Force Special Operations teams. Removable long-range fuel tanks coupled with in-flight refueling capability assures mission flexibility. Radar, FLIR (forward-looking infra-red), and other equipment allowed nearly all-weather capability.

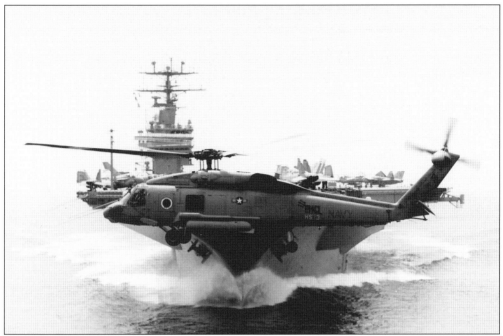

In 1992, the prestigious *Aviation Week and Space Technology* magazine judged this photograph to be the "Best of the Best" in its first photography contest. The photograph shows a U.S. Navy SH-60F crossing the bow of the USS *Theodore Roosevelt*. Sikorsky Aircraft photographer Richard Zellner took the photograph from another SH-60F.

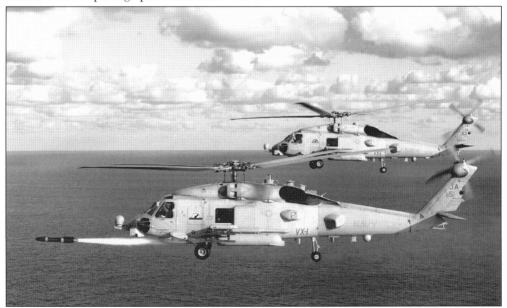

The U.S. Navy MH-60R Seahawk and MH-60S Knighthawk both have common digital "glass cockpits" and advanced flight control computers, among other improvements. The R model is the antisubmarine, antishipping attack helicopter (as seen above). The S model is the vertical replenishment vehicle. Both can be equipped for combat rescue missions. These two multi-role helicopters will eventually replace the seven different types currently in use by the U.S. Navy.

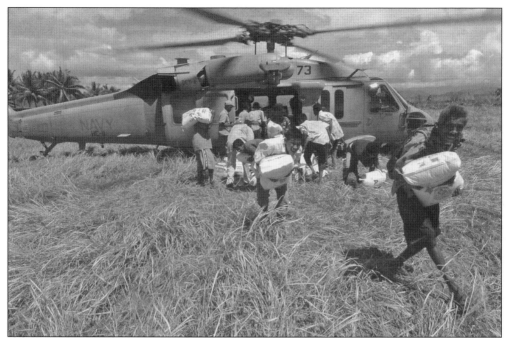

A MH-60S Knighthawk provides relief to survivors of the 2004 Southeast Asian earthquake and tsunami. Sikorsky SH-60F, HH-60H, SH-60B, and CH-53E helicopters also pitched in to overcome geographical challenges and provide aid. After Hurricane Katrina in 2005, U.S. Army, Navy, Marine Corps, and Coast Guard crews flying Sikorsky helicopters rescued 34,751 people in Greater New Orleans, validating yet again Igor Sikorsky's vision of the humanitarian mission as the helicopter's highest calling.

The UH-60M is the latest Black Hawk variant for the U.S. Army. The M uses the higher power (1,994 shaft horsepower) GE T700 engines, improved gearboxes, and wide chord composite blades, among many other upgrades to the airframe and avionics. This is partially due to the fact that in special forces service, combat-equipped troopers now weigh in at 290 pounds.

In partnership with Aero Union of Chico, California, Sikorsky Aircraft developed a firefighting kit that could be attached beneath the fuselage of a UH-60L Black Hawk. The Firehawk kit consists of a 1,000-gallon water tank, a snorkel with water pump, main landing gear extenders, and controls. Firehawk helicopters serve California's Los Angeles County Fire Department and U.S. Army National Guard units in several states with fire-prone woodland.

The S-72, also called the RSRA, was built using S-61 components. It was conceived as a flying test bed with which a variety of rotor and propulsion combinations could be evaluated. The first RSRA aircraft (tail No. 545) flew in October 1976, the second RSRA (tail No. 741) in late 1977. Only two RSRA aircraft were built.

In 1978, NASA tested the first RSRA as a compound helicopter at the Wallops Flight Center in Virginia. A variable incidence wing and a low-mounted stabilator were added. In addition to the two GE T-58 turbines driving the main and tail rotors, two 9,000-pound thrust GE TF-34 turbofans were attached to the fuselage. The speed attained was 230 miles per hour.

The second S-72 RSRA was flown at NASA's Ames Test Center and at Edwards Air Force Base. While preparing to test an advanced rotor concept called X-Wing, test article 741 was flown as an airplane in the summer of 1984. Note fuselage inscription has changed to NASA/Sikorsky. Hidden by the wingtip are the letters DARPA (Defense Advance Research Projects Agency) painted on the T-34 engine cowling.

DARPA X-Wing concept called for a circulation controlled rotor that, in theory, would take off as a helicopter. In flight, the very stiff rotor system would stop; the blades would act as wings. Due to funding problems, the X-Wing RSRA was never flown. In 1988, the RSRA's projects were terminated, and the aircraft was eventually scrapped.

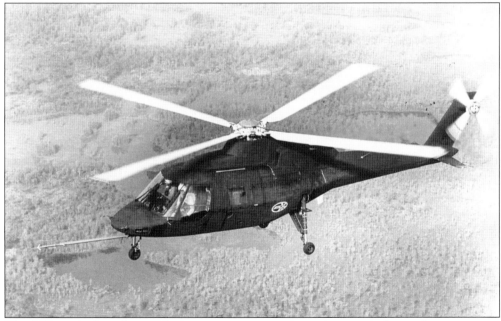

The S-75 was built under a U.S. Army contract to evaluate the use of advanced composites in future helicopters. The Advanced Composite Airframe Program (ACAP) showed significant reductions in the weight and in cost of the structure. Using S-76 hardware, the S-75 flew in mid-1984 for about one year and proved that composite airframes had great potential.

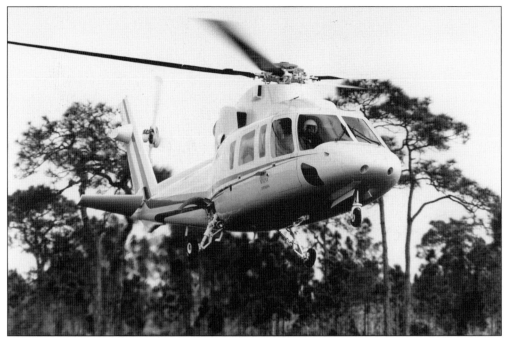

On March 13, 1977, the prototype S-76 first lifted into the air at Sikorsky Aircraft's then new West Palm Beach Flight Test Center. Designed specifically for commercial applications such as offshore utility and executive transport, it was powered by two Allison (now Rolls-Royce) CT 250 turbines of 650 shaft horsepower each. It could carry up to 12 passengers in addition to the two-man crew.

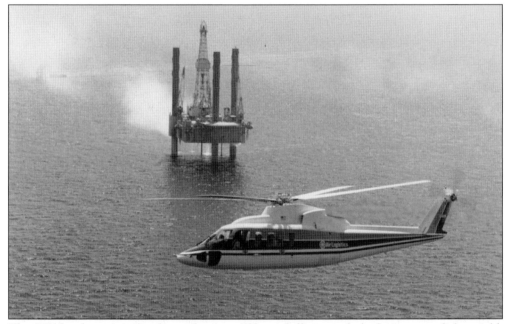

The S-76 has become a familiar sight over offshore drill rigs and platforms around the world. More than 220 operators fly some 700 S-76 variants on a variety of missions around the clock. In all, the S-76 fleet has accumulated well over four million flight hours as of December 2006.

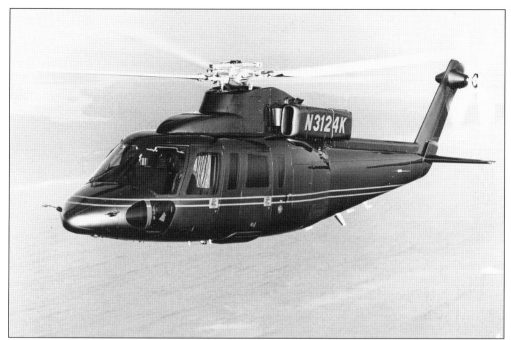

The growing popularity of the S-76, both as a utility aircraft and as an executive transport, led to an alternate power plant. In addition to the R-R CT 250, the S-76 was offered with two 980–shaft horsepower Canadian P&W PT 6Bs that resulted in additional performance and payload. This version of the S-76 became available in the late 1980s.

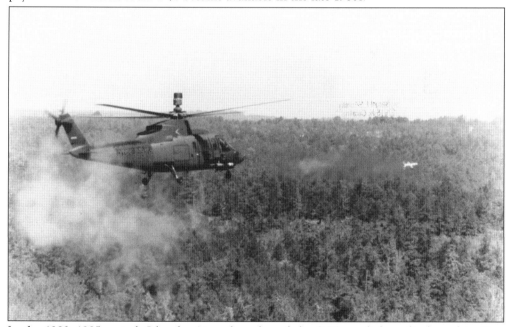

In the 1983–1985 period, Sikorsky Aircraft evaluated the S-76 as a light utility/gun ship. One S-76 was modified for the role and field tested, firing the tow missile at Fort Rucker. Note one of the earliest installations of the Hughes mast-mounted tow sight. The Philippine Air Force operates 17 S-76s, of which 12 were in the utility/gun ship role.

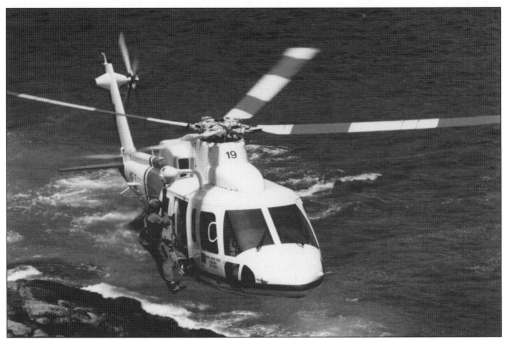

The C model of the S-76 is powered by the Turbomeca Arriel engine rated at 725 shaft horsepower. In April 1991, the first S-76C was completed and delivered to the Hong Kong Government Flying Service. Primarily used for patrol and rescue missions, the Hong Kong S-76Cs were probably the most sophisticated search and rescue helicopters in operation at the time.

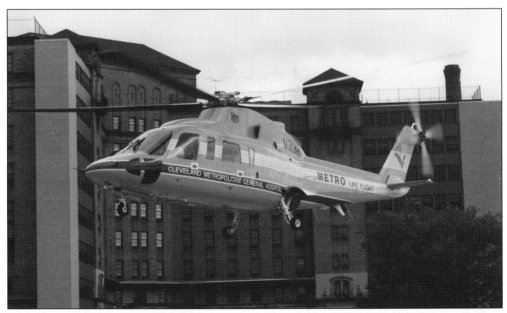

The use of the helicopter in EMS missions is steadily growing. With one of the larger cabins in its weight class and its high cruising speed, the S-76 is a popular EMS choice. The latest S-76s can transport two patients and up to four medical technicians at speed of up to 170 miles per hour. Pictured above is the Cleveland Metropolitan General Hospital S-76 EMS helicopter.

In the mid-1980s, the U.S. Army was defining requirements for a new light reconnaissance/attack helicopter. Its two-man crew would have very sophisticated electronics to carry out its missions in the high-intensity battlefield. Sikorsky Aircraft rebuilt an S-76 to mount a pilot's cockpit in the nose to test various combinations of flight controls and mission equipment. The aircraft was code-named the Shadow and started flying in 1985.

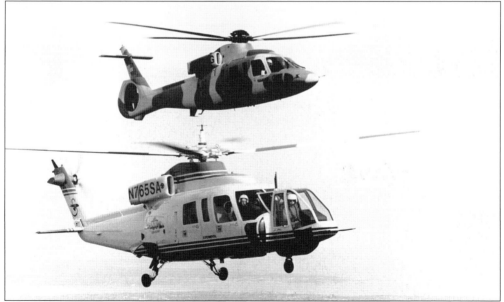

In April 1991, the U.S. Army awarded a contract to a joint Boeing-Sikorsky bid for the new helicopter, then called the LHX. The Shadow was joined by another S-76 with an experimental shrouded tail rotor, quickly named the Fantail. As the two prototypes began to take shape, the U.S. Army formally named the new LHX helicopter the RAH-66 Comanche.

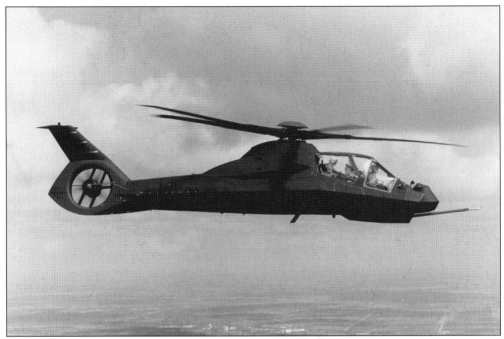

During the extensive flight test program, the two prototype RAH-66 Comanche helicopters met or exceeded all the performance requirements. However, as the Warsaw Pact fell apart, the high-intensity war threat vanished. The requirement for 1,200 Comanches was reduced to 650 in 2002, and finally the program was cancelled in early 2004.

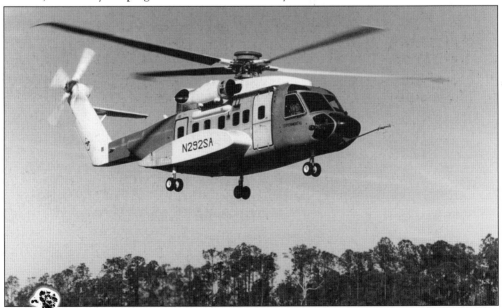

The S-92 made its first flight in December 1998, about seven years after design work started. This aircraft (N292SA) was actually the second built. The number one aircraft was the ground test vehicle, not intended for flight. The number five test aircraft incorporated all the minor changes that the flight test program suggested. The changes included lifting the main rotor 3 inches and a 16-inch cabin extension.

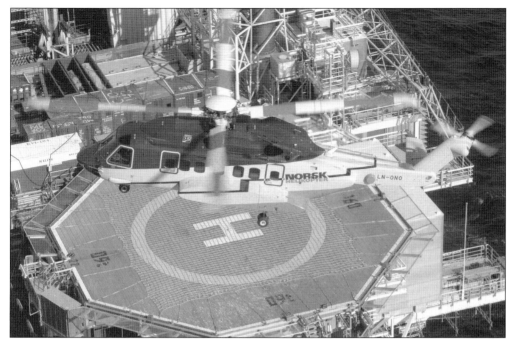

The S-92 was certified in December 2002. In February 2003, the S-92 was awarded the prestigious Collier Trophy, and deliveries started shortly afterward. In July 2004, the Canadian government decided to procure 28 S-92s as the next generation multimission helicopter for its naval forces. The picture above is a civil Norsk S-92 over an oil platform. Also note the new location of the tail stabilizer.

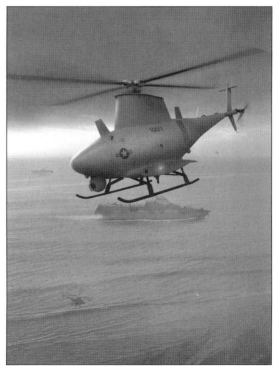

The acquisition of Schweizer Aircraft in 2004 gave Sikorsky Aircraft a stake in the light helicopter and unmanned aerial vehicle (UAV) market. Schweizer is the airframe subcontractor for the MQ-8B Fire Scout system being developed for the U.S. military by Northrop Grumman. The combination of Sikorsky's manned rotary wing capabilities and Schweizer's rapid prototyping capability holds great promise for growth in the UAV field.

In 2006, the U.S. Marine Corps awarded Sikorsky Aircraft a sole-source contract to oversee aircraft development, systems integration, test article production, and test and evaluation activities for the CH-53K, which could lead to production of 156 CH-53K aircraft to replace roughly an equal number of U.S. Marines CH-53E Super Stallion heavy-lift helicopters. The CH-53K will maintain virtually the same footprint as the CH-53E but will nearly double the payload.

Sikorsky Aircraft continues to advance vertical flight technology with development of the X2 Technology demonstrator aircraft. X2 Technology refers to an integrated suite of technologies that improve the performance of coaxial helicopters. The term X2 refers to not only the most visible feature of this helicopter (two main rotors) but also to the intended benefits of this technology—roughly twice the speed and twice the distance.

EPILOGUE

The legacy of Igor Sikorsky is alive and well in the company he founded. Although he passed away many years ago, his name still stirs memories of encounters in the aisles and hallways of the factory and office buildings. To many observers it is amazing how a large organization could continue to be so strongly influenced by the memories of one man's personality.

Once one met Igor Sikorsky, one would never forget the man or the moment. His humble, gentle, and kind manner were memorable, as were his polite and precise words, spiced with a European accent. Igor Sikorsky was also a private person. After a full day of work and meetings, he enjoyed spending time alone, walking through the woods in back of his home while reviewing a technical problem or a new design. Ideas and solutions were found while in the hills of New England, in the mountains of South America and Europe, and in the deserts of (then) Palestine and Egypt.

He truly was a renaissance man, well versed in astronomy, religion, physics, and ancient history, and a lover of classical music. Through his friendship with the great composer-pianist Sergei Rachmaninoff, he was also acquainted with many musicians and artists of the era. Privately he often admitted that he was blessed with the fact that he was born at the right time and into a family that encouraged his scientific experiments.

After the Russian Revolution, he would remain forever grateful to America, the land of the free, for the opportunity to start all over again. In Igor Sikorsky's opinion, nothing that he accomplished in America could have taken place if he did not have that freedom: The freedom to dream. The freedom to create. The freedom to risk one's own life, if the challenge justifies it. Because only with this freedom can mankind advance.

ACROSS AMERICA, PEOPLE ARE DISCOVERING SOMETHING WONDERFUL. *THEIR HERITAGE.*

Arcadia Publishing is the leading local history publisher in the United States. With more than 3,000 titles in print and hundreds of new titles released every year, Arcadia has extensive specialized experience chronicling the history of communities and celebrating America's hidden stories, bringing to life the people, places, and events from the past. To discover the history of other communities across the nation, please visit:

www.arcadiapublishing.com

Customized search tools allow you to find regional history books about the town where you grew up, the cities where your friends and family live, the town where your parents met, or even that retirement spot you've been dreaming about.